HUMANHOOD INTERNATIONAL

AND THE MEEK SHALL INHERIT EARTH

HUMANHOOD INTERNATIONAL
Timeline 2012 July - 2014 June
Ghazali PH Kho

And the Meek Shall Inherit Earth

A Book of Alternative Viewpoints, Inspiration,
Empowerment and A Clarion Call To The
Conscientious Masses Everywhere To Collectively
And Constructively Act For Sustainable Betterment!

PARTRIDGE
A Penguin Random House Company

Library of Congress Control Number: 2014919776

ISBN: Hardcover 978-1-4828-2863-4
 Softcover 978-1-4828-2862-7
 eBook 978-1-4828-2864-1

To order additional copies of this book, contact
Toll Free 800 101 2657 (Singapore)
Toll Free 1 800 81 7340 (Malaysia)
orders.singapore@partridgepublishing.com

www.partridgepublishing.com/singapore

CONTENTS

PREFACE

Bonds between humans exist, regardless of desire, willingness, and choice. They transcend ancestral or racial roots and places of origin, cultures and languages, or religious beliefs.

Human-human bonds are independent of gender –they may be between man and man, man and woman, or woman and woman. They are there, age notwithstanding, child and child, child and adult, or adult and adult.

For all these human-human bonds is born the gender- and age- neutral term **HUMANHOOD**.

All humans share the same sets of emotions, physical needs and feelings – fear and sorrow, courage and joy or happiness, aspirations and hopelessness, pessimism and optimism, resilience and surrender, repulsiveness and affinity, and the basic needs of thirst and hunger, shelter and health care.

It is only after the satisfaction of the basic needs do the more luxurious education and trappings of material-rich lives come into play.

And in all these, **the lives of the majority of the people, the so-called masses everywhere, are the most impacted, most of the time negatively!**

By the rhetoric and actions, misdeeds and crimes really, of party politicians on both sides of the political divide everywhere: the party-political bloc (mis) leading the civil administration, and the party-political bloc (mis)leading the opposition.

The masses feel helpless, unable to do anything to change their unfriendly and hostile situations, to improve their lot.

But hope lies in the presence of those conscientious individuals who uphold values, whether taught by religions or otherwise, who find the courage and

*the will to voice out, and act on behalf of the common men and women,
the masses, the people!*

Many of them operate in their immediate localities, their respective nations.
Experience and future course of plans and actions are shared locally and in
international forums. Varying degrees of success and failure are enjoyed along
the way.

These, then, are the conscientious individuals, both men and women of all
ages, everywhere who rise to the occasion and take on leadership roles with
the singular objective of securing a better environment, in all its' aspects, for
their people.

These civil and constructive approaches we call **Positive Activism.**

Then there are those, however they may be driven, and for whatever agenda,
hidden or otherwise, who harness violence, and so, destruction of assets, and
maiming and death. This is Negative Activism.

*Countries and peoples have shown that Positive Activism can achieve the desired
results of improvements for the people, and it is on these positive outcomes that efforts
are made to spread this message and employment of Positive Activism, through the
opening of minds and empowerment, and national and global partnerships.*

Read on.

Be **INSPIRED**!

Be **EMPOWERED**!

And **REPLACE** helplessness, pessimism and surrender,

With **HOPE** and **CONSTRUCTIVE, RESULTS-PRODUCING ACTIONS**,
and

INHERIT EARTH!

01 Syria and Syrians

Bashar al-Assad and All Syrians must realize that they are all citizens of the same nation, not enemies of each other. While there groups that may wantBashar out of office, likewise there are groups that want Bashar to remain in office.

Many shout for democracy, but the right thing to do would be to have multilateral monitored elections to determine which side have the majority support.

Even then, ***IT SHOULD NOT BE WINNERS TAKE ALL!***

Reconciliation and constructive engagement of, and by, all Syrians should be the way forward. All Syrians should be wary of outsiders who, on the pretext of meaning well, are only pursuing their own selfish political and economic agenda.

Humanhood International prays and looks forward to good sense prevailing on the part of Bashar and his supporters and the opposite side, and that both sides will wise up and rise above group interests toward the greater national and collective interests.

Otherwise, Syria and Syrians will suffer the fate of so many other Middle-Eastern nations and peoples - incessant and perpetual bombings and shootings, with their daily toll of maimed and dead, and the destruction of private and collective properties!

While the profiteers on the sufferings and deaths of innocents reap their blood-tainted profits from the sale of arms and other devious ventures.

02 GENTLE REMINDERS TO LEADERS OF NATIONS

2012 JULY 23

In many nations, the senseless taking of innocent human lives by deranged members of society brings forth intense grief, not only in the nations in which they occur, but also across the civil world. The feelings of unnecessary loss are felt by all.

But such loss is not only committed by deranged members of society.

Often the armed forces of nations under strife and those on missions are similarly guilty of taking innocent lives. *In countries like Afghanistan and Pakistan, there is the added dimension of unmanned drones doing this gruesome job.*

Innocent lives are similarly unnecessarily lost. Grief is similarly felt by loved ones and across the civil world. The acts are similarly uncalled for and not justifiable by any sane reasoning, certainly not by reason of collateral damage. And often these acts are on the orders of leaders of nations.

Perhaps what happened in civil society at peace can serve as gentle reminders to those in positions - that the giving of orders resulting in similar damage to other peoples' lives and in other peoples' lands is a no-go and should be stopped.

Humanhood International hopes that what had been happening can serve a useful purpose in that people, especially those in positions of authority, be more mindful of the negative impacts of their actions and stop the unnecessary wanton criminal waste of innocent human lives.

03 AL QAEDA, TALIBAN, THE 'MUSLIM' WORLD AND RAMADAN

2012 JULY 24

Anyone who declares oneself as Muslim must first learn and know the contents of the Holy Qur'an and the traditions of the Holy Prophet or Hadiths.

When the teaching of a Hadith seemingly contradicts the content of the Qur'an, the Qur'an must hold sway for the verses of the Qur'an were sent down, in part, to guide the Prophet in his personal conduct as well as the affairs of the Muslim community.

Muslims, as well as the rest of the world, must be extra careful: what is taught by a Hadith may not be what the Qur'an wants. Any Muslim must strive to follow as much as possible of the Qur'anic teachings - piecemeal, selective following must be avoided.

Al Qaeda and Taliban declared themselves Muslims and tell the world they are fighting for Islam.

But are they really?

Likewise many in the 'Muslim' world - in countries of the Middle East, Syria, Iraq, Pakistan, Afghanistan, Thailand, the Philippines, China, Nigeria, Sudan, and elsewhere.

Violations of the teachings and dictates of the Holy Book have never been more rampant than the current millennium!

From all permutations of dishonesty and immoral behaviour to outrages of the basic tenets of Islam, 'Muslims' have done it all. Worse still, even the House of Allah SWT, the suraus and mosques, are not spared - from thefts, hatchings of greedy and evil plots and other immoral activities, to killings and bombings.

No one desecrate these Houses of Allah SWT more than 'Muslims' themselves!

The cold blooded murder of innocents, non-Muslims as well as Muslims, anywhere, in the name of Jihad and cleansing run counter to the basic teachings of the religion!

The names Islamist militants, extremists and fundamentalists are misnomers.

Extremism and violence have NEVER been the way of Islam.

A fundamentalist so rich in religious knowledge and living life guided by such knowledge would not commit deeds that are against such religious knowledge.

THE WORLD SHOULD STOP USING SUCH MISNOMERS!

When people commit crimes against humanity, they are just that - COMMON CRIMINALS AGAINST HUMANITY!

Of course, criminals against humanity are NOT JUST FROM among the Muslims - some of these crimes are committed, though it should not be, with the objective of BALANCING-UP THE ACTS OF VIOLENCE AGAINST INNOCENT MUSLIMS BY NON-MUSLIMS.

This IS the holy month of Ramadan.

We see those who claim themselves 'Muslims' still carrying on their misdeeds - violent, destructive and all, the bombings and the wanton killings.

There is absolutely no recognition that the month of Ramadhan is a holy month that should be given its' due respect by good personal and group conduct worthy of such a month.

When such a basic requirement cannot be followed, how can anyone claim to be a Muslim?

A Muslim must go beyond the mere recitation of the Kalimah Syahadah, the two basic Articles of Faith. There should not be the grossly mistaken notion that all those misdeeds are for Islam.

THEY NEVER WERE!

ISLAM HAS NO NEED, EVER, FOR SUCH FLAGRANT MISCONDUCT!

04 Mitt Romney - Warmonger

Every incoming US president tries to be more hawkish than his predecessor - Barack Obama has displaced more millions in Afghanistan and Pakistan than George W Bush.

Mitt Romney's agreement to an Israeli attack on Iran during his current visit to Israel is just an attempt at one-upmanship after the Obama administration revealed US contingency plan to attack Iran should diplomacy fail to curb its nuclear program, and Barack Obama has yet to visit Israel in his current term of office.

The mutual sworn intentions of Iran and Israel to obliterate each other are not empty threats. While Israel already has a nuclear arsenal, Iran is working overtime to build one.

No one community in the world has the right to obliterate another community in an any manner whatsoever. Not all Israelis are bad and not all Iranians are good. Every community has its' good, and its' bad, members!

When Israel and the US, and most probably NATO members, engage in a nuclear war with Iran, it will be the mother of all wars. The force will be nothing the world has ever seen. Neither will the radioactive fallout. Destruction and sufferings will be on such a massive scale that a very large portion of life will be wiped out, not only humans, but also all the other living things that are unfortunate enough to be in the way.

No nation or group of nations has such a right to endanger humanity and all other living things to such dangers of unimaginable physical force and radioactive fallout from such a nuclear war.

Not the US.

Not Israel.

Not Iran.

Not NATO.

And, for that matter, *Not Any Nation on Earth!*

No nation, and no human at the head of the administration of any nation, has such a right!

Those at the head of the administrations of these nations should search their conscience and their souls, wake up and move away from such grossly irresponsible, immoral, criminal and sinful intentions!

All must realize that peace does not, and will not, come from the tips of nuclear warheads, but only from sensible, constructive, cooperative engagements!

Misplaced pride and ego, and hate and vengeance, must give way to the desire for peace, and mutual and collective well-being!

Perhaps, when the US, NATO and Israel can collectively guarantee the safety of Iran?

And, Iran, the US and NATO in turn guarantees the safety of Israel?

And, all nations with nuclear weapons take an accelerated schedule to dismantle their nuclear arsenals?

Maybe then there will be no need for Iran to develop any nuclear weapon!

Similarly, when the US, South Korea and Japan, and China collectively guarantees the safety of North Korea, along with other positive engagements, there will be no need for North Korea to develop its nuclear warheads?

Wishful thinking?

Repulsive?

Impossible?

For the sake of humanity and all other living things, and for the sake of peace and collective well-being of all, it is an option that is highly worthy of a try!

All it takes is genuine, sincere desire for true constructive peace to drive initiatives in this direction!

05 Marcos's Millions should be Returned to the Philippines People and Nation

2012 Aug 22

The conscientious, fiduciary duty of any court of law and its judge should be the expending of, not only legally but equally important, morally upright justice. It becomes even more commendable when such justice is extended to aggrieved parties from beyond the shores within which such a court functions.

The Singapore High Court's ruling that the Marcos millions belonged to the now privately-owned Philippines National Bank is fundamentally, highly flawed for the simple reason that those millions belonged to the Philippines people and nation from the onset. Ownership of the funds is of paramount importance here.

The Swiss authorities washed their hands off the affair by releasing the deposits to PNB which transferred the funds to Singapore banks including West LB.

In the service of true justice, national judicial systems should join hands and promote real global justice!

In this case, the Singapore High Court can complement and collaborate the ruling of the Philippines Supreme Court that the funds be forfeited in favour of the Philippines administration and thus its people, instead of ruling on the unenforceability of the Philippines Supreme Court ruling in the city-state.

Such judicial cooperation, collaboration and mutual support will go a long way in ensuring that real, conscientious justice can finally come to the people *of the world who are victims of their respective greedy rogue political administrators!*

06 ASSEM TRIVEDI, HUMANHOOD INTERNATIONAL IS WITH YOU!

2012 SEPT13

The arrest and detention of Indian cartoonist Assem Trivedi on charges of sedition for his cartoons lampooning the Indian administration's corruption record must be condemned by conscientious civil society everywhere.

The support of former Supreme Court judge and chairman of the Press Council of India, Markandey Katju, is welcome news and noted.

That conscientious individuals and groups in all nations continue to find the will and the courage to speak out, through whatever forms of expression, against corrupt practices and other abuses by the political leadership of their administrations, hold promise for the future of these nations and for humanity as a whole!

Greater effectiveness may perhaps be achieved when the network of conscientious civil society gets bigger and stronger, and to include the judiciary and other arms of national administrations.

Wrongdoers must be brought to book, not merely protested against!

Money embezzled through whatever means and in whatever form must be returned to national coffers!

Globally, national networks of conscientious civil groups may link up to form global networks. This will enable a global platform that can internationally bring to book these parasites of nations who may seek refuge in other lands. It calls for a higher level of constructive international cooperation and collaboration by conscientious groups.

It is high time humanity returns to the road of good behaviour. Past efforts by righteous individuals and groups must not be allowed to be in vain.

Those of us who choose to carry this torch of virtuous, ethical and moral behaviour must find strength and support from similarly inclined individuals and groups worldwide!

Together perhaps, we may achieve the results that are so desired by those before us, those among us, and those who are yet to come!

07 WILLIAM AND KATE : MEDIA FREEDOM VERSUS RIGHT TO PERSONAL PRIVACY

2012 SEPT 18

The taking and subsequent publishing of photographs in various mass media of the holidaying British royal couple is rape of the right to personal privacy. These actions confirm the descent of some media practitioners into the realms of gross disrespect, indecency, vulgarity and pornography.

Mondadori Group's, "........ they are clear expressions of the news and depict true events" are no justifications for such indefensible acts. The people behind "they do not undermine the people photographed" should have their heads examined.

The photographs not only caused distress, misery and untold embarrassment to the people photographed but also to their families, relatives and friends.

Actions such as these can only be described as uncouth, uncivil and downright uncivilized.

These newspapers and magazines should be legally cited for infringement of personal privacy and spreading pornography.

What the royal, or any other, legally- and religiously- compliant couple do, lawfully in their personal privacy, is their own and nobody else's business!

National administrative bodies that regulate the licencing of mass media can improve things by having clear and decent guidelines between freedom of expression and respect for the right to personal privacy.

With the type of violations taking place today, it is no longer the freedom of expression of the mass media but the more important and often neglected issue of downright rape of the personal rights of the victims.

Conscientious civil society everywhere can demand that national administrators start looking at these issues from the conscientious point of view, regulate and take corrective actions accordingly, so that not only is the freedom of media corporations allowed but this is justly balanced by the protection of the basic rights of individuals!

In addition, civil society can hit where it hurts the most - the pockets - by boycotting the products of these media corporations until appropriate apologies are forthcoming and assurance of non-repetition of such repulsive acts are in place.

08 CAN PROPHETS AND FOUNDERS OF RELIGIONS BE CHARACTER-ASSASSINATED?

The current furore, destruction and killings over the "Innocence of Muslims" film, raises one fundamental question - Can Prophets and Founders of Religions Be Character-Assassinated?

These were men who were way above the ordinary in terms of character, behaviour and conduct. They were men. There were as perfect as were humanly possible. *To claim that they were perfect would be untruthful and unrealistic!*

However, they were good enough to be role models not only during their time in history, but most likely till the end of time. Their value lies in their exemplary personalities as well as their teachings and conduct.

Without exception, all of them were subjected to ridicule and various forms of character derision during their lifetimes. Some, including Jesus Christ and Muhammad, continued to be scorned, mocked and 'character-assassinated', even after they were no longer around.

But really, can these prophets, holy men and founders of religions be character- assassinated?

Can the attempts of those with evil intents reduce or destroy the holiness or good characters of these individuals?

Any right thinking person will know that no amount of effort in this direction will bear fruit.

What then might possibly be the responses of these prophets and holy men when ridiculed and insulted?

Will they lose their cool and react angrily and violently?

Anger and violence are the ways of barbarians!

No, God forbid!

These prophets and holy men prayed for the forgiveness of those who lost their way, and for them to be shown the path to righteousness, and to God!

These then are the ways of prophets and holy men, founders of the religions that deliver men from their evil ways - the way of forgiveness and prayers for the enlightenment of those who lost their ways.

Perhaps in their hasty reactions to 'Innocence of Muslims', Muslims all over the world can raise their level of submission to God and may want to consider this alternative, but clearly and definitely more appropriate way of responding, the way of the prophets and founders of religions, certainly the way of the holy prophet Muhammad!

09 Global Denuclearization Should Be Accelerated!

2012 Sept 19

The current highly volatile political, economic and social environment the world over, coupled with the incessant tumultuous climatic onslaughts remind humanity that a new model for the conduct of human affairs may be necessary.

Nations that just enjoyed some level of economic success quickly moved to acquire new and more destructive arms, test new self-manufactured ones, or both, with or without the assistance of arms peddlers.

While their people struggled with the demands of modern-day living – jobs, increasingly more expensive roofs over their heads and food on the table, affordable basic healthcare, mitigation of climatic disasters, and the long list goes on.

In the face of all these, the current US administration has seen it fit that their nuclear arsenal should be modernized at a projected cost of over US350 billion, purportedly so that they can wrought far greater damage and kill off even greater numbers of the "enemy", innocent bystanders caught in between and on the sides are just their bad luck!

This money can be so much better spent on creating much needed jobs to put, with dignity, food on the table rather than to have an increasing number on food stamps, providing basic healthcare and shelter, and other amenity.

With the exception of severe natural disasters of unprecedented scale, a nuclear war with its accompanying radioactive fallout is the surest way to human annihilation.

It is not just North Korea and Iran that should not try to put together their own nuclear warheads. It is also those nations already having

nuclear arsenals that should dismantle them at a faster rate, and not try to modernize them on billion-dollars upgrading to make them even more efficient killing and destroying machines!

And, denuclearization must include a migration away from nuclear power stations and nuclear-powered vehicles such as submarines and the like. Hitting one of these power stations or vehicles with conventional weapons will similarly cause radioactive fallout the results of which would be equally disastrous.

Conscientious members of the leaderships of national administrations the world over need to pause and consider this pressing matter, the probability of happening of which is becoming higher by the day, and come up with a new model of sacrifice and constructive cooperation and collaboration, transcending narrow self and national interests, the type and level of which is not yet evident before!

10 Google, YouTube, Twitter, Facebook et al - Tools for Orchestrated Crimes Against Humanity

2012 Sept 20

Freedom of the press, media freedom, whether mass or social - these are the lame, stale, vulgar, and uncivilized phrases that lost their validity and their legitimacy when they are applied without the compulsory, accompanying qualities of responsibility, respect for the fundamental rights of, and just consideration for others, and when they are practiced on the wrong side of the moral divide of basic decency.

Crimes against humanity include all acts, words and expressions, written, spoken, visual or otherwise, that serve to destroy human society physically, morally or otherwise, through creating and causing anguish, animosity and destruction of lives and properties amongst people of the world!

The destruction of the family unit and the moral fabric of society everywhere through the orchestrated and scheduled publication of pornographic materials and the promotion of alternative lifestyles contrary to the basic teachings of religions that lead to debauchery are all crimes against humanity.

The abuses and misuses of freedom of expression by both the mass and social media to spread words and visuals that incite, ignite and inflame animosity among groups of people, that create unrest and violent disorders, that cause anguish to people by the violation of their basic rights to privacy through the publishing of materials that are otherwise pornographic under different circumstances, are all crimes against humanity.

Such irresponsible acts by both the mass and social media transgress the boundaries of basic decency, are unforgivable, and should not be allowed to continue. Conscientious civil society the world over must be united

on this, and act to show its disapproval and determination to stop this transgression.

From pressuring national administrations, boycotting products of the guilty parties, to countering with all lawful means available, conscientious civil society can, and should, bring about this new order where basic decency supersedes greed, profits and other more sinister intents!

11 Syria and the 'Muslim' World - the Way Forward

2012 Sept 24

The situation in Syria today, as was in several other Muslim nations previously, and probably will be in others in time to come, accurately depicts the actual, sorrowful state of affairs in 'Muslim' nations in general.

Torn by tribalism, Shiite-Sunni and other sectarian egos and selfishness, greedy political parties and groups, arms peddlers, and naive, misguided allegiance to power blocs, the administrators of many 'Muslim' nations get sucked into destructive and wasteful internal strives that only bring loses and immense sufferings to their own people and nations.

Sadly, blinded by their own obsession with power and material drunkenness,

they became willing oppressors of their own people, and unsuspecting, or otherwise willing, pawns of devilish power blocs with their evil intents and sinister schemes. Perhaps it is time for the people of Syria, as in the rest of the 'Muslim'

world, to wake up to the less attractive, harsh realities of their own weaknesses and misbehaviour - that unless they mend their ways, they themselves will be the real losers, and they have no one else to blame but themselves.

Of course, the 'winning' side will be so intoxicated by their temporary, artificial 'victory' that they will be unable to fathom the real fatal force that they have created and which they will soon unleash mercilessly on their own people and nation in the very immediate future - a force that will bring unceasing, and untold misery, heartbreak, suffering and death.

For Syria, winning through brute force by any group will only produce another Iraq. Years on after Saddam Hussein, there is still no peace.

Only continuous, incessant killings and destruction. The whole barrel of Shiite-Sunni and other sectarian conflicts, al Qaeda, and political and other groups all faithfully carrying out their daily dose of bombings and killings of their fellow 'Muslims' and countrymen and women, child and the elderly, and the destruction of properties, both private and national.

Being from a certain tribe, Shiite, Sunni or belonging to any other sect or group becomes more important than being merely Muslim.

How sad!

How Very Wrong!

The holy month of Ramadan was not respected. Worse still, the Houses of Allah SWT, the mosques, were not spared either.

If speaking ill of the holy Prophet is blasphemy, what do we call killing fellow Muslims in the holy month of Ramadan?

What do we call killing fellow Muslims by guns and bombs in the Houses of Allah SWT?

IT IS UNFORGIVABLE SACRILEDGE, IRREDEEMABLE DESECRATION!

And these are acts committed by Muslims against fellow Muslims, and most seriously and sinful of all, in places of worship of Muslims!

For Syrians, as well as for Muslims everywhere in the world, let there be peace. Let the process of multi-lateral monitored elections take place. And let the winning side form an inclusive administration.

Let no winner take all!

Let there be reconciliation among all the peoples of the nation, Muslims as well as non-Muslims.

12 RELIGIONS AND THE RELIGIOUSLY-FAITHFUL

2012 OCT 03

Religions are systems of faith, or belief, and worship, and are designed to bring about good personal and inter-personal conduct. Thus, those who declared themselves followers of a certain religion strive to live their lives in accordance to the teachings of that religion. *The more such a follower deviates and strays away from the dictates of the religion, the less qualified such a person is to be viewed as a follower of that religion.*

The faithful of any religion, then, will be someone who lives life as fully, in accordance to the requirements of that religion, as is humanly possible. All religions teach goodness, and all religiously-faithful, when they follow their respective religions steadfastly, stand on the right side of the good-evil divide.

In reality though, it is sad to note that many declared followers of religions live their lives quite differently from the rigors of their religions. Many just dismissed this as only being human. This is to say that to be a human being, natural and inherent weaknesses must be present and are to be expected.

Thankfully, there are humans who, through conscious choice and willing accompanying effort, conduct themselves above the basely and rise to become examples and inspirations for others that it is possible to live lives commendably. Equally gratifying, such men and women transcend geographical boundaries, ancestries and religions.

Not to be left out, and of course to be just, the group of humans who do not believe in religions but nevertheless conduct themselves well, must likewise be given their rightful places and recognition.

The terrible state of life, dreadfully corrupted, morally and physically by human weaknesses, presents a seemingly insurmountable challenge to humanity through the ages. History bears witness to the efforts of the religiously-faithful and the well-behaved free-thinkers in meeting this challenge.

This is testimony that, regardless of time, there will always be those men and women who are well aware and in control of their conscience, who allow this conscience to dictate their lives and go the extra mile in their attempts to better a society and state of life that they find unpalatable.

And, without exception, it will be on this group of conscientious men and women, of all religious beliefs or free thinking, ancestries, stations of life and nationalities, that any hope for betterment of any kind to our current sorry state rests.

It is imperative that there is common agreement for global networking, communication and course of constructive, collaborative and cooperative actions towards this common goal of collective human well-being. All platforms, vehicles, channels and other resources can, and must, be fruitfully harnessed for its realization.

13 THE RELIGIOUSLY-FAITHFUL CAN REDUCE AND STOP INTRA- AND INTER-RELIGIOUS STRIVES

2012 OCT 04

All religions teach wellness for their followers as well as for other human beings. No religion teaches evil for oneself or for others. All religiously-faithful who profess allegiance to religions ought to be living lives in accordance to this basic dictate of all religions, without exception.

It is so sad and contradictory that there are those who avowed their faith in one religion or other, but live their lives in total contrast to the teachings of their adopted religions.

Intra-religious conflicts such as Catholic-Protestant in the UK, Shiite-Sunni in Iraq, Pakistan and elsewhere, and others as a result of obsession with tribalism, or other factors, as well as inter-religious strives such as the current Buddhist-Muslim clashes in Rakhine, Myanmar and in Bangladesh, and Muslim-Hindu violence in Bangalore, Assam, India and others, can be greatly reduced and even stopped when true religiously-faithful pull their weights and remind all to return to the basic teachings of their respective religions.

Buddhism teaches the highest respect for life. Islam preaches peace and well-being for its followers as well as for others. Christianity is a religion of good conduct and forgiveness.

How then is it that people who affirmed their adherence to these religions so freely resort to violence of such nature and scale that violates the dignity of these religions and really bring shame to them. Presently, as always, no other human violates any religion more than those humans who declare themselves unwavering followers of those religions. In short, you are slapping the face of the very religion that you profess to!

Let all who see themselves as religiously-faithful of their respective religions come to their senses. Wake up! Return to the teachings of your respective religions and practice what is demanded. Be good and kind, do not be wasteful and greedy, and learn to solve differences and live in peace as your respective religions would have wanted it, as your respective religions would be dignified by it!

14 Let's Get Real With Corruption

2012 Oct 08

The recently concluded Annual General Meeting and Conference of the International Association of Anti-Corruption Authorities and the adoption of the 27-point Kuala Lumpur Declaration for mutual cooperation and international ties in the fight against corruption mark a step forward in the long march towards a honest world.

Coupled with similarly inclined judiciaries, and law enforcement and security agencies, there should be greater success in this long drawn-out war against human greed that has reached alarming proportions and is committed through more and more heinously elaborate and sophisticated action plans.

The common mutual giving and receiving of all kinds of gifts and favours as corruption is the game of the small players. The big boys of corruption devise ingenious plans under varying guises that are meticulously executed.

When society is watching closely and is vociferous, these plans are more subtle and take the form of privatization or direct-negotiation projects with guaranteed profits, vulgarly discounted national assets including land, and the like, that go to business-setups of children, siblings or cronies.

Today, corruption of this category involves very large figures, in the billions in some cases, and subject nations to their parasitic effects. But because of the political strengths of those involved, in many countries, actions that result in conviction seldom or almost never occur.

This group counts among its players presidents, prime ministers, members of ruling dynasties, the political elites and members of the upper echelons of the public administration and commercial entities.

For national Anti-Corruption Authorities to aspire for some decent degree of success, they have to be independent of the political leadership of administrations.

Subservience will be inherent when positions in the Anti-Corruption Authorities are on the recommendations of the political executives. Likewise, the undivided support and collaboration of equally political-executive-independent conscientious judiciaries, and law enforcement and security agencies are unalienable.

Peoples and nations the world over will gain when this new chapter in the development of global cooperation among Anti-Corruption Authorities inspire a similar global cooperation and collaboration among national judiciaries in the collective war against the greedy among national political and commercial administrators everywhere.

And in all these, conscientious members of civil societies will be more than willing to give their full cooperation and support.

The desired and keenly sought after end results that epitomize all these national and global cooperative and collaborative efforts will be the awareness that blatant disregard for morality and legality in the pursuit of personal gain in whatever form, in the political, administrative and business communities, is unacceptable and will be met head on with concerted and combined exertion by the various agencies entrusted with the keeping of national integrity and honesty, the safeguarding of national assets, the prosecution and conviction of the criminals of corruption and the recovery and return of monies and other national properties.

15 South and North Korea - You Are but One!

2012 Oct 09

The South Korea - US deal for missiles that can reach the whole of North Korea is another step in the US-orchestrated plan to pitch South against North. After years of instigated provocation on both sides with the sole purpose of pushing them to war, desperate efforts are now being taken to up the ante.

The Korean peninsula is but one nation. The Korean people are but one people. They all speak the Korean language, have one main religion, common food and culture. People in South Korea have relatives in the North. Likewise, people in North Korea have relatives in the South.

This sinful, unforgivable plan to cast the people of one part of the Korean peninsula against the, other - fathers against sons and daughters, uncles against nephews and nieces, brothers and sisters against brothers and sisters,....

WHAT MANNER OF SENSELESS, EVIL HUMAN ENDEAVOUR IS THIS?

Blood has to be thicker than differences in political ideology, anytime!

When a disaster hits those in one half of the peninsula, does it not tug at the heartstrings of those in the other half?

Divisive, unbeneficial animosity of the past, and hatred emanating therefrom, driven and resulting from differences in political ideology, should remain, and stay, in the past!

People from both sides should wake up to their common roots and the fact that they are but one people, one nation - merely with two different political systems.

Let not any one side try to belittle or swallow up the other side!

While others may try to convince with all kinds of enticements, the Korean people should realize that the aim is nothing but just to divide, and so weaken them.

They should come together as one and build up the people and nation as one, just as other people and nations have done before, and are still trying to do today.

Let not past differences, hurt and distrust continue to divide and weaken, and stand in the way of greater solidarity, and so greater happiness, of the Korean people!

16 There is No Militancy in Religions

2012 Oct 10

The basic aim of any religion is to guide humans in their lives on earth and their relations with each other, with other living things, and with the environment. God-centric religions have the added dimension of belief in and piety to the creator-God. All these religions have the individual and collective objectives of personal and total well-being - of self, of other human beings, and of all other living things together with the environment.

Personal and collective well-being can only come from good personal conduct and good inter-creature behaviour. Likewise, behaving well towards the environment will serve both the environment and ourselves well. It will create a sustainable healthy surrounding for ourselves and for future generations.

A proper foundation to build lives is provided by all religions when the essence of the teachings of these religions are carefully distilled and followed. Among the essence of religions will be universal virtues, ethics and morals. Always remembering these can reduce misbehaviour and greed, non-wastefulness, non-excesses or over-indulgence, thrift, consideration for others and their needs, all in healthy measures. These can lead to better balanced lives and more peaceful co-existence, between fellow humans, with other living things, and with the environment.

Consciousness to behave well towards self and all other things is the key to being civilized as opposed to being inconsiderate, quick to anger and violence, which are the characteristics of barbarians. And, ***barbarianism cannot, and should not, be justified on any ground!***

The inclination towards any widespread use of force, especially through the use of military hardware, is the domain of militants. Such resort to violence and the use of force to achieve objectives is totally not provided for in any religion.

Rather, good sense giving rise to good behaviour is the way of the religions to accomplish worthy aims.

Those who are religiously-faithful must be aware of the essence of the teachings of their respective religions and live their lives in accordance with such essence. They need to be examples of such living and spread the message, to honour their respective religions through such good living. Purpose of life can then be pursued in a constructive and civilized manner with reduced negative repercussions to other human beings, other living creatures, and the environment!

17 DIGNITY OF RELIGIONS

2012 OCT 11

The dignity of religions lies in the good contained in their teachings that is to be practiced by people who regard themselves as believers. The more such good is manifested in the selves of the followers, the more this contributes to the dignity of the religion concerned. For religions that are not God-the-Creator-centric, that is the domain of God Almighty to decide and judge.

Man would do well to just remain humble, accept his limitations and submit.

For the religiously-faithful who endeavour with great resolve to live their lives in accordance with the teachings of their chosen religion, their endeavours are a credit to their religion and safeguard its repute. Such religiously-faithful can increase the dignity of their religion by being leaders-in-faith among their congregations, propagating the living and conduct of lives as their religion would want it!

Those who declare to the world that they are followers of a particular religion but conduct themselves in repulsive contrast to their religious dictates are a sham, a disgrace to their religion and suffer their religion great dishonour. Many a time, the dignity of a religion is not smeared by others but by this group of shameful, religious pretenders and violators!

It is thus of utmost importance that anyone who declares allegiance to any religion fully understands the total implications of such declaration - the accompanying prohibitions, the rigors and the demands, and that religion is not merely, but very much more than, a set of rituals. Even the complete meanings in the performance of each ritual should be understood, appreciated, learned from and held as permanent guide to personal conduct.

Those who regard themselves as religiously-faithful and embark on missionary work to share their religion with others, similarly carry the necessity to conduct themselves with highest propriety to ensure the continued dignity of their religion. No underhand or other dishonourable manoeuvres, no false pretences, no deceitful promises or other demeaning manipulations. No religion deserves such disrespect. No religion deserves such insults. No religion has need for such despicable efforts!

All who are religiously-faithful must therefore remember at all times to conduct themselves most honourably in their attempts to carry the banner of their religion to others. It is not the number of followers that matter, it is the quality of those who declare themselves as believers of their religion!

18 MALALA YOUSAFZAI - TALIBAN, YOU SHOULD BE ASHAMED OF YOURSELVES!

2012 OCT 15

The shooting and injuring of 14-year old Malala Yousafzai continue to enlighten us about who the Taliban really are and how mistaken and wrong they are in their thinking and the things that they are doing.

Consumed by male-egoism and a lack of respect, to total hatred, for women, the Taliban's pettiness, shallow- and narrow-mindedness are reflected in their thinking and their actions, in the greatest of contrasts to the dynamism, purity and goodness that is Islam.

Demanding respect when they themselves do not respect the religion they purport to champion, the Taliban need a serious look at themselves. *Islam has an equal place for women as men, the two genders complementing and supplementing each other's gender-centric roles, providing support wherever and whenever it is needed.*

No one gender is superior to the other, no one gender is inferior to the other!

From the look of things, it will be extremely difficult, requiring the most tremendous of efforts, for the Taliban to ever understand, much less appreciate, all these.

To disregard this is to disrespect oneself as a proclaimed Muslim, and constitutes a violation of this basic dictate, and a betrayal, of the Holy religion of Islam.

Women folks, just as the men, are to be given their rightful places in families and societies, and provided with opportunities for their personal development and betterment so that they can play their roles efficiently and productively.

This is what Islam wants and this is what Islam expects from those who declared themselves as Muslims.

To enjoy the respect that they so crave, the Taliban must return to the true essence of Islam and conduct themselves with the propriety that is in Islam, not be blinded, deafened and made violent by their own backwardness, their hatred and ego, their tribalism and sectarianism, and their misogyny.

To impose one's unilateral, misguidedly-reasoned will violently on others through the use of physical, including military, force is the way of barbarians, most certainly NOT of Muslims!

The Taliban should not follow the footsteps of those whom they want to correct and so wage war on. Those miscreants who think they are militarily superior and so can wrought sufferings, destruction, and mass displacement on others, frequently get their share of such sufferings at the hands of their own deranged, and from natural disasters and accidents.

They suffer simultaneous fires and floods, tornadoes and hurricanes, earth tremors and quakes, and the like. Some of us refer to all these as ***DIVINE RECIPROCATION AT WORK!***

Let the Taliban learn humbly, and let them learn quickly, so that the damaging aspersions that they cast on Islam and the resulting misunderstanding in, and fear of, Islam by others can cease!

19 Senkaku / Diaoyu and Other Disputed Islands Are Common Properties !

2012 Oct 16

What happens when an island is equidistant between two neighbouring nations?

Or lies within overlapping continental shelves?

Or has historical records that show different ownership?

Frequently, it is the supposed natural resources that may potentially be present that act as the bait for overlapping claims to these islands by neighbouring nations.

Otherwise, strategic importance, either to the nations concerned, or to other interested, but often ill-intending nations, adds to the attractiveness of ownership.

When, after years of peaceful coexistence, self-initiated or on instigation by third parties with vested interests, people of such nations quarrel, get into economic tit-for-tats, violent demonstrations and attacks on embassies and the such, and prepare to go to war to claim ownership, perhaps it is time to return to humility and sensibility, mature and wise up, and recognize that the best way forward is the constructive way of negotiations between the parties concerned, totally and ever vigilant of the unholy incitement of those with ulterior motives!

From vocal support to economic and political manoeuvres, the selfish third parties never cease in their attempts to promote and extend their influence, or reduce and contain the dominance of those they view as threats to their global and regional power-play.

The upcoming presidential election in the United States greatly affects its international behaviour.

The challenger visited Israel, am hawkish about attacking Iran, andwants greater action on China's currency conduct.

The incumbent mulls military drill to retake an island, supposedly in preparation for the event the Senkaku Islands of Japan or Diaoyu Islands of China, depending on your allegiance, is taken by China.

This is pouring fuel on an already hot stove.

Such a line of action is totally irresponsible and unbecoming of a nation that looks at itself as a leader on the world stage and does betray sinister motives.

While some form of selfish, and so greedy, self-interest is naturally occurring and so unavoidable, there must be some clear line below which no one, not even an aspiring second term president, must fall. The world will admire the incumbent more when he insists on peaceful resolution of disputed islands, to his taking sides in any manner.

After all, **militarism need not mean strength in as much as pacifism need not mean weakness.**

Perhaps it is timely that leaders of nations can rise to a new less-selfish, more-sharing level of humaneness, and disputed islands be regarded as common properties of the contesting nations concerned, to be protected and developed responsibly and sustainably together, and whatever resources that may possibly be present, be harvested for the good of their people collectively.

The path of peace and national well-being requires great resolve, patience and endurance, accompanied, most definitely. by constructive strength and effort of similar magnitude. All these characteristics harnessed with the total wariness, at the highest degree, about collective well-being surpassing and enabling national well-being, as well as whatever enticement, promise, instigation or threat of evidently suspicious third parties!

20 HIROSHIMA, NAGASAKI AND FUKUSHIMA REVISITED

2012 OCT 22

Radioactive fall-out, whatever the source, is the same - whether from a nuclear warhead, nuclear power station or a nuclear-powered vessel - with the same immediate and long-term destructive, horrific effects on all life forms.

After witnessing the great devastation, death and sufferings from the heat and the physical force, and the subsequent radioactive fall-out, of the bombs dropped on Hiroshima and Nagasaki, it is saddest that the severity and scale of such destruction and sufferings brought on those unfortunate human beings and other living things, are not grasped and appreciated by the leaders of the administrations of nations in the manner that they should have been.

This explains the continued testing of more far-reaching inter-continental missiles capable of carrying nuclear warheads by nations such as nuclear armed India, Pakistan and their peers, and the continued attempts by nations such as North Korea and Iran in the development of nuclear warheads under the guise of developing nuclear power stations for their energy needs.

All these alongside parallel efforts by nuclear-armed nations such as the United States, Russia and China, to spend billions in the modernization of their nuclear weapons systems, money that can and should be norally better used to alleviate the challenges that their respective citizenry daily faces.

Nuclear warheads are NOT a deterrent for international misbehaviour of recalcitrant miscreants. They are guaranteed promises of the beginning of the end for humanity and the world as we know it.

The scale of the immediate destruction by the physical force and the intensity of the heat, the deaths and the sufferings will be so frighteningly severe that

the next nuclear bomb, when exploded, will definitely spell the beginning of the end.

Those increasingly trigger-itchy, nuclear-armed nations seem to forget that man is still unable to control elements of nature such as the wind and the rain.

In the event that such a nation explodes a present day nuclear explosive at an enemy nation, the wind may well just blow the resulting radioactive cloud back at it, or its' friends.

Or, the rain may wash down the radioactive cloud wherever it is, into the sea with the water carrying the radioactivity back to its', or its' friends', shores.

Then it will be its' own environment and its' own people, or its' friend, and other living things that will be the immediate and long-term victims.

Either way, *it will be that nation and its allies that are on the receiving end of the wind and the rain.*

Or, **is it that these days, people just don't care?**

As long as their so-called sworn enemies are hit, the rest are, well, acceptable collateral damage?

And, **the effort is well worth it?**

Anyway, **what is it that makes man think that he has every right to destroy and bring sufferings and death to other living things and destroy their habitats as well ?**

Japan, like other developed and developing nations China, India and the rest, seeks energy supply for its industrial and societal needs. The tsunami-triggered nuclear power station meltdown at Fukushima forced the close-down of its' other nuclear power stations pending re-evaluation. Its' energy demands has hastened the process and it has embarked on some selective reopening.

Quite untypically, renowned Japanese innovativeness have not been called into play, and instead of re-looking at the closed-down nuclear power stations, the Japanese have not embarked on large scale alternative non fossil-fuel power generation to solve its energy needs.

Perhaps it is time for them to do so, if not already.

Nuclear power stations affirm at least two reasons against themselves. None is built that can withstand the forces of harsh natural disasters.

No one can say that future natural calamities will not be as rigorous and destructive as the tsunami of 2004, or even more so.

When such an upheaval strikes, we can look forward to more meltdowns, more radioactive fall-outs, more radioactive contamination, and more deaths and sufferings for man and other living things.

Next, *nuclear power stations legitimize the enriching of plutonium that is the radioactive component of nuclear warheads.*

The equation is quite simple, really.

Take away nuclear power stations and nuclear powered vessels, and you take away the legitimate reason for plutonium enrichment.

Thus, no nuclear power stations and nuclear powered vessels, no plutonium enrichment, no raw material for nuclear warheads! Of course, until other radioactive materials are developed for use in nuclear warheads. Hopefully, by then, man would have come to his senses and abandon the ways of the barbarians!

Conscientious civil society everywhere can only use words, spoken and written, to raise its concern on issues affecting the common well-being of all. We do not choose the destructive path of violent demonstrations or militarism.

Desirous of contributing to the creation of a conscientious humanity in this third millennium, we look forward to leaders of national administrations everywhere to open up their ears, minds and hearts and listen, accept the concerns raised and act in accordance with common aspirations expressed.

Let not past deafness and inaction, pretended or otherwise, be repeated.

Let us not let the estimated 140,00 people at Hiroshima and Nagasaki, and the millions of other life-forms, that perished, and / or continue to suffer from their nuclear fall-out and that of Fukushima, be in vain.

Of all nations, Japan should be best taught by these lessons, learnt and act in the right direction, decisively and correctly.

Let us all wake up.

Let us humble ourselves and let us be a little wiser.

Let us migrate away from nuclear warheads, nuclear power stations and nuclear powered vessels.

Let us leave our legacy of moral responsibility and peace, and embark on accelerated global denuclearization on all three fronts!

21 THE NEW WORLD ORDER - RISE OF THE THIRD FORCE!

Scotland, Iceland, United Kingdom, European Union, Japan, The African Union, the Middle East, North and South America, all over the world, non-politician civil society continues to awake and take actions that are counted on to bring about the changes that they hunger for.

From writing to newspapers and administrations, to polite meetings, all have been tried. The less patient and the more physical organize and engage in street protests and demonstrations, many violently with destruction of properties and lives.

Issues range from roofs over their heads, education opportunities and increase in living costs, livelihoods, grabbing of ancestral and personal lands, to abuses of administrations, corruptions, in fact the whole spectrum of human activities and misdeeds.

All of these transcending religion, race, gender and age.

Others who feel that they have been pushed to the wall, and who are less constructive and more prone to gross violence, resort to militarism under various guises, from religions, tribalism or race-based, to political leanings. So we get our daily doses of suicide bombers, remotely controlled bombs and the like. There is no qualms about taking the lives of the innocent – children, women or the elderly.

In the face of better equipped puppet-administrations and foreign forces, all these are deemed justified, all these seemed necessary.

Should all these be?

Should this unhealthy distorted state of affairs that is taking place in so many nations in the world be allowed to continue - reminded, criticized, demonstrated against, but otherwise incapable of being changed in the way that conscientious civil society everywhere would like ?

The light at the end of this long, seemingly pitch dark, hopeless tunnel lies in the hands of conscientious civil society - men and women of all age groups, who choose the constructive, civil approach to bringing about the desired changes, to the destructiveness of violent demonstrations and barbaric military actions, and militarism.

From polite, civil written and spoken communications, crowd-sourced proposals to national referendums, this is the way of non-political conscientious civil society.

The current worry, the current fear, is that politicians in authority will not listen.

That whatever well-intended proposals will just get disposed of in the wastepaper baskets, when they are *not* in line with their unhealthy agenda.

This cannot be so.

This need not be so.

Conscientious civil society is certainly capable of more than this, capable of doing more, capable of achieving more.

From demanding to be consulted more on policy matters, putting forward proposals and being involved in the policy decision making process, to policy implementation, conscientious civil society can and should be involved.

This can be through getting the administrations of the day to agree to civil society members sitting in committees at various levels, to being appointed to the highest administrative bodies of nations.

Participation in national electoral process will be the final stage in the involvement of non-political-party, conscientious civil society in national affairs, offering the THIRD LEADERSHIP CHOICE.

Selected suitable members can stand for elections on its' own ticket. Policy voting by such elected representatives will be totally on conscience. Present in committees and commissions, this voice will represent the non-party-political voice of the people.

Should position on any issue be similar to either the administration's party-political-leadership of the day, or the party-political-alternative, that will be purely coincidental.

This then will be the new world order, the real third leadership force in nations and in the world!

It has been happening all this while in nations, albeit on piecemeal and small scales.

The next step forward is to multiply this basic effort and place it on a more galvanized, structured footing, nationally and globally, through a cohesive mechanism created to build the links in nations and finally in the world.

With the current technology, it will not be too much of a challenge when non-party-political conscientious civil societies everywhere realize this potential, this key to bringing about positive changes to national and global issues, and move coherently to make it a reality - for themselves, for their respective people, and for the sake of all of humanity!

22 NATIVE ANCESTRAL LANDS AND 'DEVELOPMENT'!

2012 OCT 29

A native of a certain place is accepted as someone born, brought up and who had lived in the place for a long while. Frequently, natives are the first to be there, and for generations, and so should rightly be recognized as the original settlers of the place and be accorded full legitimate rights to the lands they inhabit.

They live simple, unaggressive lives, working on their lands in the unsophisticated and unadulterated traditional ways of their ancestors. They learnt the secrets of their surrounding flora and the fauna, what are good for them, and what are not so good or harmful.

Theirs' is really an admirable and enviable way to live!

All other inhabitants of the land who came from elsewhere are migrants in the fullest sense of the word. They are adventurous and exploratory, seeking out new lands to eke out a living and to discover what the new lands have to offer - mainly commercially- or economically- driven.

Being aggressive and enterprising, they engage in a wider range of commercial activities and with greater sophistication than their native counterparts. Not easily satisfied, migrant inhabitants quickly extend their commercial activities beyond what is necessary for mere survival, into the realm of luxury and the sprouting of greed, many of these in the name of 'development'.

With increasing sophistication and luxury comes greater greed, and the guiding lines get blurred.

No more clear lines of demarcation between good and evil.

No more what are legitimate and what are not.

No more about what are decent and moral, and what are otherwise!

Everything become grey, permissible, allowable, possible as long as the right connections are there, as long as the right people are known, as long as the willingness to share the immoral spoils exists.

Then, never mind if there is already a dam that generates electrical energy that is more than sufficient for current needs and for the near future. Lets' make more dams and flood greater areas, for dams represent big projects, and so big profits. Never mind that in the process, large tracts of native-ancestral lands get inundated, large areas of such lands get lost, most probably forever.

After all, the natives are nobody important, the natives do not hold high positions, and above all, the majority of the natives have no links, strong or weak, in the right, high places.

Sadly, those members of native communities who were fortunate enough to get tertiary education, find the right links, get to sit in committees and even state administrations, get carried along by the swift, strong current of greed for materials and positions, forgetting their roots and going along with the greedy many at the expense of their own native communities.

This is the current scenario, the present drama of the natives of many nations in the world, in particular, the state of Sarawak, Malaysia, the current jewel in the economic crown of the world, a world drunk on materialism, a world that only sees the physical, and is blind to all else.

A world that has lost its' basic decency, its' basic elements of virtues, ethics and morals.

As long as there are physical structures to show, that is good, that is sufficient.

All else are not important.

Oh, how we have lost our humanness, our humanitarianism!

Materialism is the one and all, now and forever!

Of course, in the process, all manners of accusations and counter- accusations fly.

Who are telling the truth - the natives, the political leadership, the civil administration, the business people, the corrupt, those with vested interests ?

The truth must prevail, mechanisms must be found to make the whole process truly transparent and above board, not just cosmetically good-looking and acoustically good-sounding.

Involvement of a wider cross-section of society to provide impartiality and conscientiousness is paramount. This theatrical played out in the state of Sarawak, Malaysia is representative the world over, the only difference being the place, the natives and the projects involved.

Decency must return.

Greed must be reined in and corrected.

The hope is that politician administrators and members of civil society need to rediscover their good sides and find the will to travel this rediscovered road of morality and basic decency and correct the wrongs that have been perpetuated for so long, and return natives ancestral and to their rightful owners.

When natives choose to embrace modernity at a slower pace, or not at all, that is their basic right that should be respected by all, including from among their own who choose to modernize along with others. They can join the others but should leave their own communities to their own choices.

No one should force anything down the throats of the natives, especially to the extent of destroying their culture, their livelihood, their very existence.

23 Festival of Sacrifice and Al Qaeda, Taliban and Muslim Militants!

2012 Oct 29

The Festival of Sacrifice is an important date in the calendar of all who affirm themselves to be Muslims. It celebrates the offering of the son of a couple, Prophet Abraham and his wife, who was barren for the larger part of their marriage. They were then blessed with the son, only to be ordered to sacrifice the beloved son to Almighty God, with the willingness and consent of the equally devoted son, Prophet Isaac. By His Supreme Kindness, Almighty God allowed the family a simple recourse - the sacrifice of a lamb in place of the son.

This festival submits to the Supremacy of Almighty God, that He is The Sole Creator and Master of all, The Only Being worthy of worship, Whose Words are to be obeyed without question, even when our lives are involved.

This is the level of submission of prophets, and the level of submission to which all Muslims should aspire!

But how are Muslims treating this important festival ?

The temporary truce in Syria for the celebration was marred and violated by continued killings.

Can the guilty ones continue to address themselves as Muslims?

Can others continue to recognize and address them as Muslims?

Can and should those who continue to disrespect and violate Festivities in the Muslim calendar continue to portray themselves and be recognized as Muslims?

And, the suicide bombers, for whatever reasons.

There is no suicide in Islam.

There is no taking of innocent lives, especially those of children, women and the elderly, in Islam.

Life and death are in the absolute domain of the Almighty.

No human has the right to decide death for innocent lives.

All such acts of suicide, and disrespect and violation of festivities of the Muslim calendar, are an affront on, and a sacrilege of, the holy religion of Islam.

And of all things, by people who regard themselves as Muslims, who think they are upholding Islam and protecting its' sanctity.

They could not be more mistaken.

They could not be further from the true path.

Al Qaeda, Taliban, and 'Muslim', never Islamic, militants everywhere, if you want to carry the banner of Islam, return to the true way, the way of constructive peace, not the way of violence, the way of destruction, the way of barbaric militarism and the wanton taking of innocent lives !

So help you God!

24 INSTIGATORS OF ARMS PROLIFERATION ARE EVIL AND DEVILISH!

2012 OCT 30

It is extremely sad when an award-winning, internationally syndicated columnist on the Middle East and South Asia chooses to misuse military knowledge to portray nations as militarily weak and so unable to defend themselves, and totally dependent on others for their own defence and survival.

In addition, neighbours are to be viewed as threatening enemies that seek to obliterate and annihilate.

All these with the intention to instigate the expend of hard-earned billions on the acquisition of offensive defence, billions that can be better spent to improve the livelihoods of the people.

What a waste of military knowledge!

What a profligacy of literary prowess!

Even when arsenals being promoted are conventional, such actions are most irresponsible and unbecoming, and when nuclear warheads are promoted, the instigator can only be described as evil and devilish.

Knowing the horrendously devastating power of nuclear weapons, yet nations are incited to acquire them?

Such people are satanic! Oh, the evil of man!

God-given gifts should be used for the good of man, not the promotion of evil.

The ability to possess good military knowledge and the creativity to write well are gifts that deserve better - to be used responsibly and constructively to contribute to world peace and the safety and security of man and the world, not the reverse. Any war that involves nuclear warheads will spell the beginning of the end of humanity and the world.

The sheer, tremendous destructiveness of the physical force, the extremely intense heat, the huge, radioactive clouds, and the unpredictable natural elements - the rain and the wind, all of which cannot be mitigated, will together surely doom humanity and the world.

While great efforts are continually attempted by civil society all over the world to save man and his world from the horrors of nuclear conflict, through calls for the accelerated dismantling of nuclear warheads, the migration away from nuclear-power stations and nuclear-powered vessels, we have to contend with seemingly literate people who choose erroneously to promote nuclear weapons!

25 Myanmar – Lets' Stop the Senseless and Unnecessary Carnage First!

2012 Nov 05

No religion advocates and condones senseless and unnecessary taking of lives, not Buddhism, not Islam!

The immediate first step in the conflict in Myanmar between Buddhist locals and Muslim Rohingyas is the stoppage of such killings and the burning of homes on, and by, both sides.

As in all human clashes of opposing factions, it is best that neutral peacekeeping forces be present to keep the opposing sides apart to prevent further violence against each other. When the senseless and unnecessary carnage and destruction are halted, talks can commence to find an amicable resolution to the quarrel.

Basically, the Buddhist locals view the Muslim Rohingyas as immigrants who have settled in their land, and compete with them for sparse livelihood and commercial activities. Compounding the situation is the committing of crimes, including rape, by criminals.

The hatred that has grown on both sides through the years only needed small sparks to ignite into full-blown bloody racial strife.

The truly, religiously-pious on both sides of the divide, who are guided in all they think, say and do, by the true teachings of their respective religions, need to take the lead. The opportunistic imposters who pretend to champion their respective religion and people, and who engage in inflammatory rhetoric, must not be allowed to play centre-stage.

The basic tenets of both religions - to value life and to treat others with compassion, fairness and consideration, when applied, will pave the way for peaceful settlement.

Let each side nurture and safeguard the dignity of its' respective religion, and let collective peace, safety and well-being be the objective and driving force for this noble effort.

Let the criminals on both sides be appropriately countered by the full force of the laws of the land.

Aung San Suu Kyi's neutral stand is wise and constructive, even if it disappoints the international community and displeases the quarrelling factions, and represents true moral leadership.

Maintaining neutrality while awaiting determination of the truth, even when one's own community is involved, and then acting firmly but tempered with, and accompanied by, compassion, fairness and consideration - these are the hallmarks of a true, moral national leader.

Let all others respect the sovereignty, the maturity and the wisdom of Myanmar's new administration and its' people in this first internal test.

And, let no quarter, whoever they may be, impose anything on, or instigate in any manner, the people, and the nation, of Myanmar.

26 FRANCE'S PLANNED SAME-SEX MARRIAGE AND ADOPTION LAWS

2012 NOV 06

Newly-elected political leaderships of administrations frequently take the position that they have been given the mandate to propose new laws, at times on controversial issues. Had these same issues been high-lighted in their election manifestoes, election results might have been quite different.

France's current tussle, between its' newly elected political leadership and its' proposal for same-sex marriage and adoption of children by same-sex couples, and followers of its' various faiths, and conservative politicians and citizenry, falls under such ambience.

As with many other contentious issues, the proponents argue on the grounds of basic and equal rights - here, the rights of those who want or allow same-sex marriage and adoption - versus the rights of those who are against. In some places, even followers of religions soften their stand just so as not to lose members of their flock with such inclinations.

There cannot be deliberations about individual rights without the corresponding considerations of the rights of others, especially those with differing but non-religion-complaint orientations. These deliberations must come together with the caveat that the rights of a minority cannot be upheld to the extent that the rights of the majority, even by one, are violated.

Meeting the rights of a minority must never be allowed when it results in the unjust and incorrect imposition of those rights on the majority.

Thus is the case of the right to freedom of expression of the mass media against the right to personal privacy of legally-legitimate and religiously-correct couples such as Britain's Prince William and his wife Kate.

The mass media cannot uphold their right to freedom of expression to the extent of violating the right to personal privacy of the couple.

Where issues at hand are legally-legitimate and religiously-correct, effort may be expended to meet the needs of the minority.

Laws may be passed in national assemblies of man. However, whatever are religiously-incorrect remain religiously-incorrect, whatever elected administrations or declared followers of religions may decide and do.

Legally-legitimate but religiously-incorrect issues are best and wisest not be pursued whether by newly-elected administrations or by those who have been in office for a while.

It is not man that humans need fear.

For those of us who believe in the Divine Being, it is He Whom we must take the greatest care not to transgress.

If, and when, we choose to remain egoistic, pompous and stubborn, then we take it on ourselves to await His Divine Retribution.

27 CONGRATULATIONS AMERICA!

The conscientious world congratulates America and Americans on the successful and peaceful conduct of its presidential election, without major acts of violence though tainted by trivial lies and slurs on, and from, both sides.

May the immense authority and tremendous responsibilities of the office of the President of the United States of America be discharged, taught and guided by lessons learnt from his first term, and with the same care, compassion and consideration for other peoples as he had shown for Americans who were victims of Super storm Sandy.

Can the world dare to aspire for a leadership that has learnt that the destructive tool of war or military action is no sure fire way to economic revival, but is instead a process that brings untold and unnecessary sufferings to the millions affected, via the mass displacements and the sheer brutal physical destruction, violence, and abuses?

Militarism is not the only, or best, way to rein in unbalanced and misguided murderous militants, whoever and wherever they may be.

Sincere and peaceful cooperation and collaboration with well-intending groups, whether governmental or otherwise, can similarly bring in the desired results, while remaining the more civilized and constructive, and therefore the more preferred, choice.

For the peace- and security-loving, may the second-term president apportion less of the American budget on the military, including the modernization of its nuclear arsenal, and instead promote the acceleration of the disarmament of nuclear-warheads, and the migration away from nuclear power generation and nuclear-powered vessels, all beginning with America herself.

May the second-term President lead the world, by example, out of the dangers of nuclear power!

The civilized world looks forward to the second-term President leaving a legacy of humble, constructive and humane leadership that serves not only Americans but also the rest of humanity.

It is a heavy responsibility but we are confident that President Barack Obama is capable, and up to it!

Congratulations once again!

28 Muharram Ushers in the Muslim New Year!

2012 Nov 14

For many people, the dawning of a New Year represents an appropriate time for self-reflection - where one had been and where one is heading, what one had done, what one failed to accomplish, …......

A good time for contemplation, and a proper time for making resolutions which will form the basis for the coming year, the driving force that will help us proceed.

Depending on one's station in life, the depth, the breadth and the complexities of plans and strategies follow the goals that are targeted to be achieved, the weaknesses and mistakes that are to be corrected, and the areas where improvements are desired.

And so it is with kings, presidents, prime ministers, people in administrations and commerce, and the common man and woman.

Unless of course they are louse and louts who live parasitic, unproductive lives, even for themselves.

Muslims too venture on such endeavours on the arrival of a New Year, except perhaps those Muslims who feel that this is another of the decadent practices of the West and so is out of bounds to real and good 'Muslims'.

That, reflecting on behaviour and actions from the recent past year, admitting and wanting to correct mistakes, planning for improvements to areas of weaknesses and elsewhere, at the coming of a New Year is Western decadence?

Perhaps, *much like education for girls is, and so should not be thought about, much less spread?*

And, **women have no rightful place in society, much less of the dignified type ?**

Or, **are these really so?**

We ask of these Muslims - **Where is the dynamism of Islam, the religion that can more than serve the best of men, and women, till the end of time, and probably beyond?**

For those who are unable to continually embark on this process throughout the year, year-in and year-out, the onset of a new year presents an opportune time to do so.

This has always been in Islam, except for those who allow cobwebs of narrow- and shallow-mindedness to form in their minds and obscure proper and rightful productive thinking, and the shackles of tribalism, sectarianism, past animosities, greed and lust for power and materialism, militarism and destructiveness, chauvinism, whether race- or gender- driven, around their thick necks.

Let this Muharram, and every Muharram that comes in the future, remind Muslims of Islam, and the responsibilities toward it when one utters the Kalimah Syahadah and takes on the faith of Islam, and the title of "Muslim".

Thus, *whether kings, presidents, prime ministers and all else, no position or title is important, only that of* **MUSLIM** *and* **ONE'S OBLIGATIONS TO ISLAM.**

For all the past atrocities committed by those in positions of authority, Muharram is a good time for retrospection and retroaction. Limitation of term of office to prevent abuses is a commendable place to start.

In the Muslim world, much of the troubles that resulted in violent uprisings by the masses, centred on this abuse with its resultant corruption and cruelty toward fellow countrymen, fellow Muslims.

No one is indispensable - no king, president, prime minister, religious or political elite, no one. When the humility inherent in Islam is present in Muslims, limiting term of office will be embraced humbly and wholeheartedly.

It is only when one is saturated with pomposity, and so arrogance, lust for power and greed for materialism, that one feels indispensable, that only one is capable of leading and administering, and cling on to positions for dear-life, often subjecting to the most horrendous cruelty, and destroying, all challengers in the process.

Retrospection by all Muslims on the dawn of Muharram can correct misperceptions about Islam by all, Muslims and non-Muslims alike.

For Muslims who are from Muslim families, it is faith by inheritance. Feelings of compulsion, insincerity and lack of choice are best addressed through a re-examination of the faith and a re-affirmation. This can and will correct the helplessness brought on by feelings of compulsion and frustration via one's faith by inheritance.

Misbehaviour by one's parents, seniors and peers who are fellow Muslims, can similarly cast aspersions on the religion.

The same, without exception, goes for all the other religions.

Thus, *proper behaviour, as the religion teaches and so expects, and wants, can reduce calumniations and wrongful inaccuracies about the religion, by all alike,*

the believers and the non-believers.

Incumbents must conduct and improve themselves in line with the tenets of the religion, to be reflective of, and accordingly, do justice, to the religion.

This benefits the incumbents more than it does the religion.

Likewise, *jihad, the war in the name of Islam, the religion that preaches peace.*

It sounds and seems so self-conflicting!

Islam, a religion of the Creator, the Almighty, who could have all believe in Him had He so wanted it, but Who chose instead to give man his freedom to choose what and who to believe in, and, consequently, take full responsibility, and be totally accountable, for it.

Does Islam need defending?

Does Islam need things to be done for it?

Islam is a religion of the monotheist Almighty.

It needs no protection.

It is indestructible.

It is self-sufficient.

Jihad is only for the benefit of Muslims, not Islam.

Jihad is against the forces of evil that work extremely hard to lead man astray, especially those who declare their faith in the Almighty.

Jihad at all, including peaceful, times, does not mean militarism and suicide bombings, and the wanton destruction of property and lives,

Jihad means proper personal and inter-personal conduct according to the guidance, instructions and laws of Islam.

Such conduct that is wholly enforced by the restrictions and prohibitions of the religion and which will serve Muslims well and hold up as good examples and reference for others, Muslims as well as non-Muslims.

The commissioning of jihad must not, at any time, cause discomfort and fear, and as a result, alienate others from Islam!

It stems the tide of evil and establishes goodness, not be a willing accomplice of, and assistant to, the propagation of sin, cruelty and evil to man.

Let Muharram, like all the other festivities of the Muslim calendar, be respected by Muslims, as they all should be.

And, *let it serve its' rightful, constructive purpose together with all the other festivities - that of contributing to, and spreading, goodness instead of being disrespected, as all the other festivities, and spent committing all kinds of sins, destruction, murders, and killings.*

29 SAVITA HALAPPANAVAR, A VICTIM OF THE 'PIOUS'?

2012 NOV 19

The intention of religion has always been good - guiding man towards virtuous behaviour and proper conduct towards other human beings, ensuring safety, security and individual and collective well-being.

There is never the objective of religion to pose danger to, or worse still cause the death of, humans through its teachings or their strict adherence.

Thus, religious piety should, in itself, be a beneficial thing, not only to the practitioner, but also to others who should come in contact, spiritually, physically and emotionally, directly or otherwise.

It is therefore a paradox that something that should be good, and ensures the well-being of humans, instead causes agony, suffering and even death.

Orthodoxy has to be tempered with sensibility.

The course of applying wisdom to beliefs should in no way lessen the sanctity of the basic tenets of religions or reduce their conformity.

A religion may be against the induced termination of a human pregnancy.

It is not wrong for this to be balanced by allowing it, albeit in special circumstances, chief of which is the danger to the carrying mother-to-be.

A normal miscarriage is a spontaneous, natural termination of a pregnancy. The unviable foetus, placenta and other contents of the uterus are normally removed as soon as possible to prevent infection and posing a danger to the mother-to-be, in addition to relieving her of pain and agony.

Refusing to provide such a basic service to the mother-to-be on the strength of religious beliefs, or laws formulated under such beliefs, constitutes a serious violation of the basic reason for the existence of the religion itself - that of ensuring the quality well-being of all,

Religious-faithful of any religion must humble themselves, open up their minds, and see the dynamism of their respective religions. Wisdom and basic sensibility must be employed.

Ireland has been famous for its medical education, not only for the Irish or citizens of Britain, but also for students from all over the world.

Let the leaders of Irish society and the Church re-visit this issue as well as others,

Let them be blessed with humbleness and basic wisdom so that they are able to distinguish the genuine, permissible exceptions to their orthodoxy.

Let not the religion be marred by human weaknesses on the pretext of religious devoutness.

Let not the passing of Savita Halappanavar be in vain.

Let others who may find themselves in similar circumstances of need, wherever they may be, in the presence of whichever religious group, not suffer the same fate, brought on by a misguided and definitely wrongful conforming to orthodoxy.

May Almighty God Forgive and Bless her soul. Amen.

30 Global Movement of Moderates - Kindly Walk the Talk!

2012 Nov 27

Promoting the principles of moderation and peace-making, and promoting peaceful resolution of conflicts and coexistence amidst cultural diversity are all noble objectives worthy of support by all conscientious human beings. When such are the guiding tenets and driving force for the future of the world and humanity, then there is hope.

However, *when the proponents of such good dictates themselves budget for billion-dollar national arms acquisition, on whatever pretext, it does cast serious doubts and aspersions on the sincerity and the real intents.*

People who go around proclaiming goodwill and peaceful coexistence must be consistent in words and actions. Not shout peace at every opportunity but at the same time endeavour to acquire modern weapons of greater destructive power on massive budgets.

National defence and deterring hostile marauders are but simple, naive excuses.

Stimulating arms race with neighbouring nations and desiring to exhibit superior fire-power are more valid likely reasons.

Reducing arms stock-pile, dismantling nuclear-armed missiles, discouraging arms development, production and build-up, and lessening national defence budgets are all more suitable, more constructive accompaniments of the call for greater peaceful resolutions of misunderstandings and conflicts, as well as peaceful, secure coexistence.

Let well-intending words be substantiated by equally appropriate actions, nationally, regionally and globally.

Let hypocrisy be reduced and replaced by simple, humble honesty and sincerity in thoughts, words and actions.

Where the collective peaceful, secure well-being of peoples and nations are concerned, ***these are compulsory.***

31 Corruption - the War Continues

2012 Nov 27

Battles may be won occasionally but the war against corruption necessitates its widest definition possible, to include all variations of corrupt practices beyond the simple mere giving and receiving of money, material and favours, and wherever it may take place - the public administration or the business premise.

Of course, *the most visible will be in the public sector, especially when the guilty are the leadership of the administration, political and civil, and the spoils are the biggest.*

The abuse of positions for gains - personal, spouse, children, relatives and cohorts - or even organizations and political parties, conflict of interests, mixing business and politics under the pretext of administration-industry or public-private sector cooperation, privatization, management-buyouts, and the multitude of other permutations, represent the cross-section of corrupt practices that offer opportunities for address.

When all are clear of what constitutes corruption, the task of fighting it becomes better defined.

It will require the close, honest cooperation and collaboration of all - civil society, public administrators, industrial players, the security and enforcement agencies, the judiciary,

All will need to be of the highest moral fibre and courage.

All must want a clean administration more than personal glory and gain.

With greater awakening and desire to see positive change in this war, nations are now more poised for victory.

With continued national actions and international cooperation and collaboration with, and between, similarly-inclined individuals, groups and administrative agencies, victory will come to peoples and nations.

32 SYRIA, AMERICA, CHINA, INDIA.......
REIN IN YOUR GREED,
YOUR BARBARISM!

2012 DEC 04

Disturbing but not unexpected news -Bashar al-Assad preparing chemical weapons to be used against his opponents with America warning unspecified response, and India preparing naval vessels purportedly to protect its economic and maritime interests in South China Sea, specifically its Oil And Natural Gas Corp in the Nam Con Son Basin, after accusation by Vietnam's Petrovietnam of Chinese sabotage.

Bashar al-Alssad will lose whatever legitimacy of, and support for, his administration, if he proceeds to unleash his chemical weapons on his opponents, whom some of us still view as mounting an illegal, criminal challenge.

It may be late to talk about peaceful resolution for the conflict, after so much of atrocities, killing and damage are committed by both sides. But really, the only hope is peaceful resolution through internationally monitored elections.

Syria is very likely to end up as another Iraq, and Bashar al Assad as another Saddam Hussain, Muammar Gaddafi,

The daily bombings and killings will likely continue as in Iraq, though it need not be on any lesser scale as at present, what with both sides going all out to annihilate the other.

Rotten, barbaric developments, these!

Enemies of Iran and the Shiite sect await with abated breadth for Iran to miliyarily waddle into the conflict. *Let Tehran not miscalculate or overestimate its own military might.*

Iran's direct involvement will double the excuses for Barack Obama's open, undefined response, surely much to the delight and ecstasy of Israel and Netanyahu, and bring all closer to the prophesies of doom.

It seems a natural law that when riches grow, it is accompanied by corresponding growth in paranoiac insecurity!

Thus when nations develop and acquire greater riches, more missiles and other weaponry of greater destructive powers are developed or purchased, tested and deployed, ready to demolish the enemy, real or imaginary, mostly the latter.

This is the case with both China and India, and a host of smaller nations that go on weapons-buying sprees with their new-found wealth. Likewise the developed nations.

It does look like barbarism never left us from the days of Genghis Khan and Attila The Hun.

Nations that have been fortunate enough to develop and see their national per capita income grow should learn humility, learn to be more satisfied, and, most importantly, learn to have consideration for other human beings in other lands who too have a right to live and to enjoy a certain minimum level of life.

When the aggressive developed nations go on hostile commercial expansion and acquisitions in other lands, what is going to happen to the economies and peoples of those nations?

When China exports to all nations of the world on their advantage of low prices, what happens to the products of other peoples?

Likewise the service professionals of India ?

Perhaps now is as good a time as any other for political leaders to look beyond their own shores, to also look at the welfare of the peoples of other lands, to become regional and global statesmen who consider the economic

interests and well-being of peoples of other lands while striving to improve that of their own.

All the while mindful of the heavy responsibility of not promoting commercial greed and unforgivable barbarism, and their inescapable accountability and retribution …......

33 Kleptocracy - the Administration of, and by, Thieves

2012 Dec 13

Chambers Concise puts Kleptomania as An irresistible urge to steal, especially objects that are not desired for themselves, and are of little monetary value.

Going by this definition, straight-forward kleptomania would then not be a crime, since the object of the act, though stolen, is not driven by a desire to possess or for its meaningful monetary value. Rather, it is a medical condition that warrants understanding, empathy and treatment.

Then, there are those who steal because of their desire to possess, as well as for, the monetary value of the spoils involved. These are petty thieves, and also greater rogues who grab land and plunder national treasuries. They are the immoral greedy with their insatiable appetite for name, money, materialism and debauchery.

Multi-billionaires who amassed their piles through political patronage, and by bribing their way, buying out public officials, bending and by-passing rules and laws alike, supported by corrupt, dishonest public servants, ever eager to dirty-line their deep pockets, morality, legality and criminality notwithstanding.

When these rogue multi-billionaire business people turn political leaders for national administrations, they bring along their immoral ways where, together with their equally base cohorts, indulge in debauchery, even with under-aged girls. Then through their wasteful extravagance, they ruin economies and render nations bankrupt.

These plunderers, embezzlers and misappropriators easily worm their ways into high positions of presidents, prime ministers and the like, where they are joined by their rotten public-official comrades-in-arms.

The Chambers Dictionary *describes such administrations as kleptocracy - a government by thieves, a thieves' regime, a country with such a government, or a body or order of thieves.*

Kinder people define kleptocracy as an administration by status-, rent- and personal-gain seekers at the expense of the people they administered.

When nations get into financial difficulties, austerity drives in the wrong places get hastily put together and let loose. The result - street protests that turn violent, with destruction of personal and public properties, injuries and unnecessary loss of lives, and nations get set back by years.

This is the manifestly common scenario the world over. And all because of thieves in local and national administrations. All because of kleptocracy - the global, age-old scourge.

The counter measure - awakening of conscientious civil society, deeply rooted in universal virtues, ethics and morals, and therefore upright and of high integrity, that takes greater charge of administrative matters, locally and nationally. Not merely satisfied with being the providers of crowd-sourced ideas that then await politician administrators' decision, unsure whether they will see the light of day, much less be implemented.

34 INTERNATIONAL COMMUNITY - STOP YOUR HYPOCRITICAL CHARADE!

2012 DEC 17

North Korea's recent rocket launch, that it claimed is a satellite, attracted a barrage of condemnations from the international community, as a provocative disguised long-range ballistic missile test by a rogue nation. Similar launches by China, India, Pakistan, European and Western nations do not entice response of similar nature.

The international community's partiality towards selective condemnation of certain nations reduces its credibility and betrays its' insincerity in wanting to promote a conducive environment for peaceful reconciliation of differences with the nations concerned.

This will only lead to greater distrust, further alienation, and deterioration of opportunity to reduce hostility and military development.

Likewise, there is no hue and cry now that Japan's right-leaning politicians have come back to power with promises of changes to its pacifist constitution, and enhanced hawkish security.

Or the sounding of alarm bells when American naval forces are positioned in the Middle and far-East together with the deployment of batteries of Patriot missiles from Turkey in the Middle-East to Japan and South Korea in the far East, and elsewhere.

The multitude of military moves such as the supply of arms to forces seeking undemocratic overthrow of regimes, and land, naval and air military support in all their permutations, represent indecent effort at destabilizing nations and regions.

All these warrant the most serious and the loudest of condemnations and reprimand. Sadly, what are heard are, at most, muted mutterings in passing.

Nations are called rogue nations when they dare to stand up against the wishes and designs of certain nations and groups of nations. Threats of military action follow closely on the heels of social and economic sanctions.

Is it any wonder when these affected nations come together and attempt to develop weapons for their defence and survival ?

This is not supporting the military developments of these nations but an assertion that when threats are removed and genuine effort made sincerely towards peace and inclusion into the international community, hostility and distrust can be lessened and in their place, international cooperation and collaboration can be collectively endeavoured to meet the increasingly intense challenges that humanity and the world are threatened with.

Such challenges increase by the day - food and water shortages; mutated, more deadly diseases; depleting energy resources; environmental pollution and severe climatic disasters; violence, militarism and barbarism; greed, moral decay and other human misbehaviour;

Conscientious and visionary leaderships at national, regional and global levels can urgently review the right way, realigning towards balanced, constructive and peaceful national and international priorities.

35 THE APPROPRIATENESS AND USEFULNESS OF THE LEGAL DEATH SENTENCE !

2012 DEC 26

Savagery, barbarism, greed and other guises of evil that drive brutality, torture and other physical disfigurement, and other forms of human sufferings, including death, warrant the most appropriate of legal responses.

Those who choose to cause physical and mental inflictions on others through their mindful activities invite legal reciprocation befitting the severity of the damage they caused.

There cannot be, there should not be, second thoughts, or dilly-dallying, about the legal punishment that befits the crime committed.

Illicit drugs, the very serious destroyer of the world-wide community, the cause of untold sufferings of societies - from the drug addicts themselves who die from overdose, needle- and drug-contamination, in their homes and on the streets, the broken homes, the thefts and robberies, many lethal, causing death and sufferings to victims and their families, the innocents who die in cross-fire between warring drug gangs, the acute sufferings of their loved ones,

Considering all these, nations that impose the legal death sentence for drug possession, couriering and trafficking, are more than justified in their effort to contain, reduce and rid society of this all threatening and destructive menace.

Never mind that some blood drug-money are used, in part, to finance arms-purchasing for independence movements, or topple disobedient regimes, or the development of more destructive weapons for marginalized, rogue nations, or freedom-fighting militias.

The ends do not justify the means.

But, the legal sentence justifies the punishment for the crime committed.

Likewise for those who resort to taking the lives of others through whatever devious means - from the use of difficult-to-trace poisons, sheer brutal violence or the use of sophisticated weaponry, including smart rifles and drones.

Murder by any other name, through any unilateral justification, remains unchanged, as simple, cold-blooded murder.

Those who choose to commit murder, consciously give up their right to their own lives and capital punishment for them remains proper, appropriate and justified.

People who choose to carry out violations against fellow human beings must be prepared to receive, in return, reciprocation of similar nature and intensity.

Those who sit in the comfort of air-conditioned offices, criticize and oppose capital punishment should go down to the ground, mingle, talk and feel the emotional, mental and physical pulses of the victims, if they are not already dead, and their loved ones.

Let that open up their eyes, their minds and their hearts to the severity of the realities of the crimes perpetuated.

In this era when humans choose to lose their humaneness and let loose their savagery on their fellow humans, for whatever reasons, the intensity of punishment for the guilty must be appropriate and befitting the cruelty of the crime.

No hesitancy and weak responses from national administrators.

No wavering and doubtful stammering at the behest of arm-chair non-realists.

36 As 2012 Sets and 2013 Beckons, Has Humanity Learnt? Has Humanity Improved? Just a Wee Bit?

2012 Dec 31

The setting of 2012 witnessed heart-wrenching incidents -bus gang-rape by criminals of a victim who subsequently died, shooting deaths of school children by a deranged member of society, citizens of nations killing each other daily due to political and sectarian differences, killings from drug-related wars, human suffering from natural disasters - extreme cold, devastating storms, floods, earth-quakes, displacement of millions from vested-interests-driven military activities,

Really, sad happenings that take place the whole of 2012, and the years preceding, and very likely in 2013, and subsequent years to come.

Mainly human cruelty towards fellow human beings, rooted in primitive savagery and personal and group bigotry, derangement, apathy, selfishness and greed,

Indeed, humanity has failed to learn, as always, and sadder still, continues to deteriorate in both personal and public behaviour, station in life notwithstanding.

Is there no hope?

No light, however dim, at the end of this long dark tunnel of human life on earth?

Not when man has not been successful in mastering his primary primitiveness, his basic barbarism.

Not when personal and group greed-driven-selfishness remain the motivator and mother-of-all-actions, in both private and public fundamental lives.

Not when personal and group status, rent and other gains stay all-consuming and all-engulfing.

Not when material-drunkenness rule lives and wasteful consumerism continues to govern the day.

Not when orthodox bigotry prevents the recognition of women as equal partners of men on earth, to be accorded similar respect and opportunities, in education and other spheres of personal development, and protected, not abused.

And when women, who rise to the occasion and become independent, providing for self and family, invite resentment and often uncalled-for violence against themselves from men who have forgotten their own responsibilities to self, family and society.

Not when humanity has yet to expand "crimes against humanity" to include any form of atrocity against man by whatever means, including illicit-drug production and sale, weapons development, proliferation and deployment, that aggravates national and regional conflicts and increase militarism, military intervention illegally legitimized by lope-sided United Nations resolutions and sanctions that increases national and regional instabilities and mass displacements, in addition to daily killings and destruction,

Those who chose to commit the most brutal of cruelties, including the infliction of death to other humans, forfeit their rights to their own lives, and in turn place such rights in the hands of those entrusted to legally upkeep the well-being of society and its members.

Not when corruption has yet to be expanded to include all forms of abuse that allow the acquisition of ill-gotten gains by criminal politician- and civilian- administrators.

Not when the response to nations stepping up their militarism is the reciprocal increase in militarism by others, weakly disguised as modernization and such, and the abandonment of pacifist constitution and eventual rearmament by yet others.

When it should have been to demand the first party to decrease its militarism.

Not when national political leaders insist on the hundreds of billions in national military budgets be spent on military upgrading and causing misery and sufferings in foreign lands and on other peoples, instead of financing the building of homes for the homeless, providing food and healthcare for the destitute, aged and otherwise, establishing industries to provide jobs and grow the economy,

Can we wake up in the new year ?

Do we want to wake up in the new year?

Do we want to become more civilized than we were in 2012?

Do we want to reduce the sad happenings that took place in 2012 and the years before it ?

Can we return to values-centric existence and values-driven conduct regardless of who we are, and what station in life we have achieved?

Can we move to curtail our individual and group excesses, greed, selfishness and indifference?

And replace them with empathy for others and a readiness to cooperate and collaborate constructively?

As our little contributions towards lessening the planetary and human emergencies of drastic climatic and other natural upheavals, population explosion, food and water shortage, poverty and disease, and sheer base human barbarity, that challenge us individually and collectively?

Let the new year offer a fresh insight and a new reminder to each one of us, that there can be hope for an improved year, not in terms of an increase in materialism and status, but in the things that truly matters, that qualify us to be called humans.

37 Taking Up Where We Left Off : Hello 2013!

The year 2012 bore witness to the myriad of human handiwork in all the spheres of his endeavours, some beneficial and commendable, many repulsive and destructive, to the point of life-threatening and life-taking.

Cycles of habitual human misdemeanour that brought pain, suffering and death to himself and to the multitude of other living things that together inhabit mother earth.

Is 2013 going to be any different ?

Will 2013 be any different ?

Results achieved will be constant when objectives remain the same, matters are approached with the old mind set and processes are executed in largely identical fashion.

We will harvest likewise whatever it is we similarly sow!

For 2013 to be different in the positive way, to see improvements in societal, national and global matters of significance -

human emergencies of moral decay, population explosion, poverty and increased disparity, disease, energy, food and water shortages, greed and general debauchery, corruption, increased militarism and savagery, illicit drug abuse,; and planetary emergencies of accelerated polar ice-cap melting, rising ocean-water levels, global warming, devastatingly violent storms, increased frequency of earthquakes and volcanic eruptions,;

mind sets, objectives and processes have to be meaningfully changed.

While in the past, personal selfishness and greed for status and material gains are the driving forces, may these be replaced by greater consideration and magnanimity for others.

Where egos and hawkishness propel destructive militarism, may humility and pacifism take their place, sowing peace and constructive stability in their path.

May education be the major tool to create awareness about, and correct, religious and racial bigotry, and universal virtues, ethics and morals, together with humaneness and humanitarianism be taught in their place.

May the international community voice out strongly and impartially, whenever, wherever and whosoever increase militarism by whatever means -

testing of a new missile, modernization of existing weaponry and defence systems, of military hard- and soft- wares, arming conflicting sides or a nation and people with a history of extreme barbaric cruelty to other humans in the quest for imperialism and dominance, and today seeks to abandon their pacifist constitution and rearm themselves, without remorse or regret for their past atrocities, to the extent of wanting to rephrase an earlier statement of apology for their war-time brutality, …......

May the developed and newly-developing nations and economic giants wake up unto themselves and give a thought to the less developed, less aggressive nations that are struggling to grow their little economies.

Let not the big and the strong see all and take all!

Can we dare to see greater international constructive, cooperative and collaborative effort between a greater number of nations in our attempt in mitigating the increasing challenges facing us individually and collectively?

Can conscientious civil societies everywhere rise to the occasion and play a more meaningful leadership role in the affairs of their own nations and of the world, refusing to continue being misled by misbehaving politician administrators and kleptocrats?

Can conscientious civil societies everywhere, especially in those nations that had committed the most cruel of brutalities against fellow human beings, lead the way in which violence and militarism, and dominance, whether by gender, dynasties and elites, or whatever other unacceptable basis, in politics, business and elsewhere, are not options?

Can it be shown that constructive words can, and should, replace bullets and rockets, and the negotiating table can, and should, replace the battlefield, for the resolution of whatever form of differences, between groups in a nation, and between nations?

Dare we envisage, dare we hope, to see the unification of North and South Korea, and of Taiwan and China, and of ……. as single nations though with differing component political ideologies, as tiny steps in the march towards **the SINGULARITY of a CONSCIENTIOUS, PLURAL HUMANITY ?**

38 Conscience of Nations, Conscience of Humanity!

2013 Jan 10

The desire to change matters that affect human lives drive thinking humans into planning and taking actions.

Founded on the right premise, objectives and actions will bring about positive changes and the realization of improvements. Based on less commendable propositions, actions and objectives will result in unfavourable outcomes detrimental to the well-being of humanity, other living organisms and the rest of the world.

Conscientious activism based on universal virtues, ethics and morals, correctly and constructively harnessed, will bring about the desired beneficial changes.

Sadly, conversely, the wrong kind of activism, often encouraged and assisted by those with evil ulterior motives, brings in its path destruction and suffering that sets peoples and nations back decades, repeatedly proven in the modern world in Iraq and other Middle-Eastern nations, Afghanistan, Pakistan, Africa, South America,

Serious effort is continuously mounted to destabilize nations such as China, the Korean Peninsula, India and Pakistan, through activism platforms that carry a wide array of names – democracy, human rights, civil liberties, the environment, wild life, freedom of speech, of expression or artistic pursuits, you name it.

Non-political civil society and the masses need to be more discerning and not be driven by herd-mentality to the point of blindly following unhealthy crowd-action disguised as whatever nice sounding causes.

Properly founded and equipped with clear distinguishing capabilities, civil activism has acted as conscience of peoples and nations throughout the history of man.

Today, civil activism, both positive and negative, is very much alive on the widest range of causes and impacting lives and administrations as never before.

In the face of unscrupulous administrators, political and civilian, who work hand-in-glove with obscenely greedy business people, civil activism provides a useful avenue for non-political people involvement in the administration of nations, as a viable alternative to the political process thus far dominated most unhealthily, and, in many instances, most disastrously, by unfit, corrupt politicians.

At this juncture, evaluating the progress and accomplishment of civil movements in nations and the world, perhaps it will dawn on those of us who hold dear such civil effort, to realize that more can be achieved for things wilfully neglected, more correction of the wrongs propagated and perpetuated by the selfish, greedy and incompetent few in power, the elites, the dynasties, and their cohorts.

Non-political civil activism is ready for the establishment of greater national and global linkage and networking for wider awareness-creation, and increased collective and collaborative action to bring about the desired impact on administrations towards aspired people-centred goals.

The prospect of conscience-driven non-political civil society running administrations of nations as a more conscientious form of governance offers a tempting promise of better things to come - for humanity, for all other living creatures on earth, and for Mother earth herself.

It is a prospect that, consciously or otherwise, man has been harbouring throughout history.

It is an option that many has embarked on, with or without realizing it.

It is an endeavour that can be taken further to its full fruition of dominant non-party-politician civil society role in national and global administrations.

It is a promise that is worthy of the most serious critical evaluation by all non-party-political civil groups.

It is a promise that can become reality.

It is left to us, non-party-political conscientious civil activists to make it happen!

39 INVITATION TO CONTINUE THE RELAY OF HOPE!

2013 JAN 14

The history of man continues to be written by the presence of men and women everywhere who carry the torch of hope for humanity. While some remain confined within the boundaries of their immediate communities, others have traversed nationally and globally.

These are men and women optimistic and motivated enough to see beyond the darkness brought on by the weaknesses of others, especially the kleptocratic elites who run administrations and businesses.

While humanity and the world continue to be challenged by man-made and natural catastrophes of increasingly armageddonic proportions :

mutated epidemic causing viruses, tribesmen butchering rival tribesmen for land and water, military conflicts and militarism, ethnic cleansing, illicit drug production and peddling, population explosion and its accompanying challenges, all manners of corrupt practice and abuse of authority, all forms of crimes against humanity by the militarily powerful,

In the face of all these, and drawing inspiration from those who persisted and endeavoured before us, Humanhood International, invites similarly-inclined individuals and groups everywhere who share this common love for humanity, this common belief that conscientious improvement is possible for all, to come together, to let our soft individual voices be heard loudly together, to let our small effort join force to achieve our common collective aspiration of peace and well-being for humanity, through conscientious, constructive and collaborative exertions.

Humanhood International is a non-political, not-for-profit global vehicle and platform, currently based in Malaysia, that draws its strength from conscientious

civil society everywhere, with the belief that greater participation by such conscientious civil society can bring on the realization of our collective hope for conscientious responsible administrations producing the desired national and global peace and well-being.

If you are reading this post and feel there are those in your circle, or elsewhere, who may be willing to join us please feel free to communicate through:

humanhoodinternational@yahoo.com, and ghazaliphkho@yahoo.com

Let us do our humble little bit - for ourselves, for our loved ones, for humanity and for all the other living creatures who share this earth!

40 What Must It Take?

2013 Jan 15

Epidemics that kill millions, nuclear missile exchanges between India and Pakistan, or Israel and Iran, that similarly will kill millions and has the certain ability to wipe out humanity and the rest of the living things on earth, eruptions of military hostilities between Japan, China, America, Russia, ……., tsunamis of greater destructiveness than that of 2004, or tropical storms of greater ferocity than Sandy, catastrophic earthquakes and volcanic eruptions, severe droughts and roasting heat-waves in some places and incessant rains and massive flooding in others, ……?

No! This is not the doomsday prediction of December 21 2012, the end of the Mayan 5000-year calendar. This is the reality of the current world that carries the highest possibility of becoming true, pursuant to the correctness of the action or inaction of humanity.

The current outbreak of flu that hit many nations reveal the vulnerability of humanity to the ravages of disease. Not handled properly, this epidemic can easily bring death to even larger numbers than flu had done before.

Taken in the right vein, it presents a valuable opportunity for nations to come together and try and save lives, alleviate sufferings, to a more significant level of human cooperation, a more commendable display of global humanitarianism.

Hostilities on so many fronts rub sorely in on our pronounced primitiveness and savagery that shockingly run counter to the technological advancements that we supposedly have achieved.

There is no improvement in civility and humaneness.

91

No generation of greater hope, or brighter future, for the safety and security of man and his fellow creatures on earth. No more meaningful legacy, and nicer and sweeter stories to tell our children, and their children.

Is it so beyond us?

The continued deterioration of personal and public behaviour of the common person?

The persistent hawkishness and barbarity of leaders of administrations, both political and civil?

The never-ending full-throttle pursuit of materialism in the name of development?

More like destruction really!

What with its wide-spread strangulation of the environment from deforestation, industrial smog, and chemical and other wastes!

Is it so difficult to rein in our ego, our greed and our barbarity?

Why is it the legitimate opposition in one nation, and rebels and terrorists in another?

And one is given full military support while the other is subjected to disproportionate military assault?

Why is there partial. prejudiced, and sanctioned interference in certain cases, while in others ethnic cleansing is allowed unopposed and unabated?

When will those who take it on themselves as global policemen who make unilateral summary judgement, sentencing and execution, with total disregard for innocent collateral damage, see their own follies, their own shortcomings, and their own inadequacies ?

Why is there this stubborn, bigoted refusal to acknowledge and correct the causes of dissatisfaction that resulted in the drive towards destructive militarism of large segments of people in so many nations, propagated by militant groups who profess a certain religion?

Why is there this misguided will to sow dissent and animosity among groups to destabilize ?

Which will can only be accurately described as evil ?

In the midst of all these, can conscientious civil society remain complacent with doing nothing, or just having impotent street protests?

Or is conscientious civil society everywhere, singly and collectively, capable of more ?

Some of us do feel that more can be achieved, more should be achieved!

When single voices are small and soft, perhaps joining into a chorus can be louder and so better heard!

When single effort are insufficient to bring about the change hoped for, perhaps joining hands, and putting shoulders together, can move bigger obstacles and set in motion the changes that are only so far dreamed about and longed for.

For those of us who are optimistic diehards, we continue to hope, we continue to work diligently in the pursuit of this hope, locally and globally, knowing that, sooner or later, voices will be heard, action will follow, and results will be achieved!

41 MALI, OH MALI!

The bloody drama that is currently being staged on Malian soil is reminiscent of many that had taken place, is being repeated, and will be a preview of others yet to happen in nations the world over. The small differences will be the players, the stages and the victims.

Here, they are France and the European Union - collectively Nato, and America, again, Mali, Tuareg and those suspected of having links to Al Qaeda, Taliban and What-Have-You, real or probably mostly imagined.

The key star players had always been America and the European Union. Canada, Australia, with other smaller nations occasionally joining the cast. Pakistan, Afghanistan, Thailand, The Philippines, and *other nations of Asia, the Middle-East and Africa, South America,*

God, that's literally the whole world!

Together with their tribesmen and people. Never mind if the majority of them are just struggling, mostly simply and difficultly eking out the most meagre of living.

They can all be suspected of having unhealthy links with hostile militant groups.

Key elements remain the same : the strategy, the approach, the manipulations, the deceits and lies, the flimsy excuses for disproportionate, all-out destruction of threats - all stay constant.

The brutal slaughter and maiming continue to bear the unmistakable traditional hallmarks of gross human bestiality against his fellow man.

No sympathy.

No feelings of compassion.

No feelings of love for fellow man.

No remorse.

No fear of repercussions in whatever form, Divine or otherwise!

We are the strongest.

We are the most powerful.

The world and its weak inhabitants are ours to decimate, to toy with, any which way and how, as only we may decide.

Vested interests- economic, territorial, ego, military.

Simple primitiveness that continue to wield a stranglehold on those who regard themselves leaders in the societies they are in.

The power players, the ultra-egos - who cannot lose, who must not lose.

Who, though past their era of colonialism, must maintain a political hold on the locals who replace them as administrators, really, weak, dependent puppets who otherwise would not have the capacity or ability to run their own administrations, despite all their clamouring, and all the seeming fiery struggle.

In the midst of all these, there are those who decided not to take things as they are anymore, and who want to do things differently, with greater dignity and think that they can do things better.

Desirous to be self-determining, unwilling to be subservient to those who administer them, more so when they are from a different ancestry, speak a different language and subscribe to a different religious faith. That these

people happen to declare themselves followers of a particular faith can be purely coincidental.

After all, a lot of what is taking place points to one-bloc of nations and one group of people of a particular faith taking it out, excessively, and grossly savagely through military superiority, on another group of nations and people that supposedly follow another religious faith.

Of course, having inflammatory, religious orators who fuel and ignite religious fervour to explosive proportions, do energize things and drive uncontrolled emotional and irrational decisions considerably.

But, surely, the people who want the outbreak of conflicts most, must be the political leaderships who need to revive economies to maintain popularity and stay in office, and those who stand to gain through the consumption of arms - the arms developers and producers. and the peddlers.

How else can arms stockpiles be depleted?

How else can newly developed, more destructive weapons be sold and commissioned?

How else can bottom-lines of arms-industry corporations be improved?

Most certainly not when there is peace, and disagreeing people on opposite sides sit at the same negotiating table and manage to find ways to get around their differences and their disagreements!

These, then, are the broad outlines that form the plots for all the barbaric dramas staged mercilessly in so many nations of the world – past, present and well into the future.

Dramas that descended to the lowest level of barbaric human mistreatment of fellow man. Behaviour that most certainly will cause our better behaving ancestors to turn in their graves.

It is not far-fetched.

It is not exaggerated.

It is not off-the-mark.

Rather it is a lot of what is perceived to be true, rightly or wrongly. And sadly, a lot of it drives militarism - extreme, fanatic, destructive and suicidal.

To think that to problem-solve, we are taught to identify key causes and treat the causes, not the symptoms or the results.

That the way to alleviate these disgraceful cycles of wasteful violence, killing and destruction all around the world is to correct the inaccurate perceptions by doing the morally right, though unpopular, not the politically right and popular.

That constructive engagements with all groups, respecting differences and the desire for dignified self-determination, while offering positive inputs for collective peace and well-being, stand head-and-shoulder above military might, as the tool for global understanding and the way forward.

Let not the fact that this approach is not followed betray a serious lack of honesty and sincerity on the part of those capable of addressing the situation effectively.

Let the true desire be the honest and sincere pursuit of dignified peace and humanhood among men and women everywhere, and not any less than honourable intent!

42 STOP THE INCESSANT TERRORIZING OF HUMANITY!

2013 JAN 29

It is sad that man should work so hard at terrorizing his fellowman, with his arsenal of bombs and chemical, biological and nuclear warheads, and the uninterrupted development and deployment of more destructive weapons. Flimsy, age-old excuses are repeatedly used by all quarters to justify the eruption and perpetuation of military conflicts and disproportionate responses.

Innocent humans everywhere continue to remain victims of armed quarrels that neither really involve nor benefit them. All they receive in turn are violence of the greatest bestiality with its accompanying suffering and death.

Current stockpiles of weapons of all sorts, really the weapons of mass destruction of the West, are being used on all fronts, and new weapons of greater destructiveness are being developed, sold and deployed.

Poor Humanity!

Men and women holding the highest positions in national administrations do not show the qualities worthy of their positions. In their places are barbarism and brutality to be inflicted on weaker others, and in their own lands. Diligently terrorizing other human beings wherever and whenever their unilateral mob decisions may take them.

Those nations with their huge stockpile of conventional and nuclear weapons that forever hold humanity to ransom, perpetually causing humanity to exist, and to live, in the shadows of devastating armed- and nuclear-conflicts - these and the leaders of their administrations, are the true criminals against humanity.

It will be in humanity's interest for those who sit in the International Court of Justice and the United Nations to take cognizance of this basic fact, this fundamental reality.

But then, what can humanity expect ?

Who can humanity really count on ?

Certainly not on those whose appointments totally hinge on non-independence and an unquestioning willingness to hear and obey the powers-that-be, the people and nations that dictate matters in their own interests, with total partiality, with repulsive impunity, to the detriment of all others.

As a result, nations like North Korea and Iran, too work overtime, to come up with their own nuclear warheads, ever eager to join the ranks of their fellow criminals against humanity, ever keen to intensify terror on the unfortunate rest-of-us.

With so many sworn enemies, each determined to obliterate or annihilate the other at some suitable time, we will all be hard-pressed to enjoy a good night's sleep knowing full well that tomorrow may bring that much dreaded, but seemingly unavoidable, nuclear-powered end-of-the-world-Mother-Of-All-Wars.

Either between sworn enemies Israel and Iran, America and Iran, North and South Korea, India and Pakistan, or whatever convenient combinations thereof, with nations of the European Union - France, Germany, etc, and China and Russia, waiting most impatiently on the side-lines ever-ready to capitalize, ever-generous to pour in whatever out-dated but still destructive weapons necessary.

And why not?

Many birds can be killed with this kind of stone.

The rest of us - we await the full force of the nuclear explosions, we await our fate for the radioactive clouds that will most probably blow our unfortunate ways.

Just what kind of existence is this?

What kind of life?

Awaiting the most horrifying of deaths, on the most massive of scales ?

Are we really so hopeless ?

Are we really so helpless?

Perhaps only those of us who are sufficiently conscientious, courageous and motivated to act, hold the answer.

As we continue to voice out, to remind, to reprimand, to call for greater global awareness and joint-action. Those who will continue undiscouraged, determined to achieve our global goals of accelerated dismantling of nuclear, chemical and biological arsenals, stopping development and deployment of new weaponry of greater destructiveness, in short to ensure that the arms industry is a sunset industry, alongside good, moral and peaceful administration of nations.

43 Syrians, Egyptians, Yemenis, Iraqis, Libyans, Other Middle Easterners, Pakistanis, Afghans,....... Wake Up And Wise Up!

2013 Jan 31

That the Muslim world is in turmoil is an understatement. The daily suicide and other bombings in the market places, the bazaars, the mosques, the police watch-posts, the army posts,

These are must-happens.

It is now almost impossible for nations like Pakistan, Afghanistan, Iraq, Libya, to ever be able to enjoy a day without the explosions, burning and destruction, infliction of injuries and taking of lives.

Mainly on innocent citizens - men, women and children, unconnected with the power-struggle, political manoeuvring and foreign-designed and orchestrated operations to destabilize.

Powerless. Not in any position to do anything to change their personal and societal safety and well-being. Several nations - Syria, Egypt, Yemen, Mali, Sudan, Nigeria,....... hold the highest potential to join the ranks. It is saddest that, by design, these nations are Muslim-majority nations.

The world is divided into the destabilized Muslim-majority nations and the vulturous Western bloc that abuse and misuse Christianity for their evil intents.

This is NOT the voice of Islamic fanaticism or extremism, or fundamentalist militarism that is speaking out.

This is a statement-of-fact that the world and its people need to be reminded of, and repeatedly. Reminded tirelessly so that it can serve as a wake-up call to the truth to what are taking place in these nations.

After waking up, and hoping against hope, that there is this slimmest chance that reality may dawn on all and drive people everywhere to take the necessary corrective actions to salvage whatever that is left, that is still worthy of being saved.

This is NOT Christianity and Christians against Islam and Muslims!

Neither is it Islam and Muslims against Christianity and Christians!

This is simply Evil against Good, and its henchmen against the innocents!

This call is even more so for the people of the affected nations - those who are already in living hell, and those keenly on the way. That those who pit brethren against brethren, and countrymen against countrymen, for whatever reasons and justifications, are no saints. Indeed, they are the accomplices, the most willing henchmen, of evil itself.

That nations, like families, should not break up on any account. That differences can and must be approached and settled constructively and peacefully. That while one side may win by a majority, however slim, such victory must be respected by all, the losing side must not lose all but given their due place in national affairs and their appropriate role to play.

That *only peace can ensure a dignified existence and a meaningful life for all!*

Without doubt, it takes a great deal of negotiations and counter negotiations, and other works, but the end result will be worth it!

The alternative, the fruit of refusal and failure to back down, to compromise, to find common grounds for coming together, is total, daily wanton anarchy, perhaps to the end of time.

Of course, it will include the opening of doors to foreign forces whose only, very involvement is the perpetuation of their unholy interests and the establishment of disguised puppet administrations in furtherance of their selfish causes.

Thus, it is that citizens of Egypt, Syria, Yemen, Pakistan, Afghanistan, are once again called upon to reassess their situations wisely, not let supposed tribalism, sectarianism, chauvinism, or other evilly-fired-up grounds, to continue driving your nation-breaking stances and readiness for worsening internal strife.

Let not more Muslim-majority nations join the ranks of nations-in-violent-turmoil.

Let the common citizens wake up and wise up, and let compromise and constructiveness ensure peace and a meaningful, dignified existence and life!

44 LEADERSHIPS OF VIOLENCE SPAWN COMMUNITIES WITH VIOLENCE!

2013 FEB 04

Though shocking and heart-wrenching, it should come as no surprise that repeated acts of unprovoked and unwarranted violence against innocent members of society everywhere - children, women and old folks, are committed with shocking regularity, as if strictly scheduled.

The reasons, the landscape, the methodology and tools, the victims, the perpetrators may be different. But the essence of the act remains the same.

Simple, downright unwarranted and unnecessary violence, any which way it is looked at!

It may be just an individual executing physical violence on another - a husband, father or brother on a wife, a child or a sibling.

It may be criminal violence in the commission of a crime - rape, robbery, murder, hate-crime,

It may be a deranged member of society inflicting pain, suffering and death on innocents.

Or it may be violence on fellow countrymen, or supposed sworn-enemies, in the course of political and other conflicts, for whatever reasons, through the use of sophisticated weapons, including satellite-guided missiles, drones and smart rifles.

So acts of violence against fellow human beings take all forms. on all pretexts, and through the employment of all types of appendages.

And, why not?

After all, *violence is an inseparable part and parcel of modern culture?*

Without exception, we have it in all spheres of human activity - the mass media, all forms of communication and entertainment, in administration and resolution of disagreements and conflicts - personal. national and international, violent mass-, group- and personal- behaviour, To the extent that the most dangerous job on earth is reputed to be the personal assistant of a certain most ill-tempered supermodel.

So it is, that icons and leaders everywhere - actors and actresses, singers, writers, directors and others in the entertainment industry, and the politicians - together they form the world's most high-profile, and therefore most visible and emulated, and those in key-roles in families, industries and organizations, whenever they practice violence, they serve to embed this culture of violence in the common man and woman, young and old alike.

To alleviate this distressing occurrence, a return to peaceful ways in both words and actions seem compulsory and inevitable, from schools and other educational institutions, mass media, entertainment including virtual games, personal and societal behaviour, to national and international administration and conduct.

Gun possession and control is a necessary first step towards a peaceful society through the prevention of gun-violence.

When national constitutions stand in the way, there is this thing called constitutional amendment. When an amended constitution guarantees the liberty to possess arms as a fundamental right, to rectify, there is also this matter called amending the amended constitution!

After all, national constitutions are drawn up to serve nations and their people, and not the other way round. So when the need arises for a constitution to be amended to cater to current needs, and yet remain useful right into the future, then without hesitation, it should be done.

Internationally, the disproportionate application of superior weapons in the unilateral engagement of others conceived as threats to national security, even when such others are so far away, more often than not, breeds contempt and drives others to the extent of the willing, ultimate sacrifice.

It does not help when the perpetrators are always from one bloc while the perceived enemies are always from some other bloc.Thus it is that we end up having daily suicide-, road-side and religious-site bombings.

Of course, most of these take place in other people's lands. It is only when some of these shootings and occasional bombings happen in one's own land, one's own backyard, that the local public out-pouring of grief and in member nations of the same bloc, raise concern and initiate action.

When they occur in other lands, at most, only murmurs are heard, and promises of investigations and what-not. To compound the situation, drones are now offered to select accomplice countries after the movement of numerous batteries of patriot missiles and naval armadas.

You reap what you sow!

When you sow violence all over the globe, do you expect peace in your own homeland?

Those who want peace and security for their own people need to ensure peace and security for others, whoever they may be, wherever they may be!

Thus, it is that leaders who do not want violence for their own people must honestly and sincerely embrace whole-hearted peace in their leadership, their administration and their international relations!

45 POPULATION EXPLOSION AND THE DEVOUT!

2013 FEB 06

Religion teaches good behaviour, self-control, consideration, duty, responsibility, thrift, non-wastefulness,......., respect for, and quality of, life, Those who regard themselves devotees of particular religions must necessarily be conscious of their duties and responsibilities to the religion they profess. With such consciousness reflected in their personal conduct and their interpersonal interactions in the community they find themselves in.

Properly followed and diligently practiced, devotees and their families should lead lives of quality. Not materially and technologically drunk or obsessed. Not excessive in any way or manner, in thoughts and deeds. Just reasonable lives of good balance between the various mundane demands and spiritual obligations. Certainly not imposing orthodox bigotry on others and refusing to open up to other viewpoints and reasoning, however sound they may be.

Respect for life requires us to show the fullest responsibilities to ensure that life, once present, enjoys reasonable quality in all its aspects. To accomplish this would demand that those who increase their family members possess the means to provide reasonably for the needs of the offspring they bring into this world.

Society, being made up of so many different economic levels, will witness the satisfying of this basic responsibility to different degrees of success.

While variance in success within permitted levels is to be expected and acceptable, there will be instances when it is beyond the capability of the pair of parents to provide the basic necessities. This must be realistically accepted and to then nonchalantly *expect and demand that God Provides, is both most irresponsible and unbecoming!*

Of course, there is never an iota of doubt that *if He should ever so Wishes, He Can, and is more than able to, Provide!*

Thus, *while abortion is repulsed and disallowed, except in the most excruciating of circumstances, such as when the maternal life is seriously threatened, family planning must, most earnestly and rightfully, be given its' due place!*

Family planning is the scheduling of when to have children, through the employment of various means - natural rhythm or other natural means, and artificial or chemical and instrumental contraception.

It is not synonymous with, nor is it the encouragement of, promiscuity, debauchery and other immoral sexual relationships, or irresponsible parenthood!

Neither is it abortion nor infanticide!

Rather, harnessed wisely and correctly, family planning enables well-planned dutiful parenthood that comfortably spaces out the having of children and their quality up-bringing, whether one is in the best of economic and/or physical circumstances, or otherwise.

Thus, *responsible family planning, by whatever means, is definitely more religiously correct, and socially, morally and legally right. Certainly, it defeats the irresponsible abandonment of children, new-borns and others. Better still, it prevents and reduces criminal abortions, by whatever means, and murderous infanticide, both females and males, regardless of the reason.*

Religious devotion does not compel the resolute surrender of such a useful approach and tool. Rather, religion encourages the usage of whatever sensible means and techniques that can help ensure the well-being and quality of life of the devotees and their families themselves!

Thus it is, that leadership of administrations of nations that seek to introduce and implement national policies of birth control are not unnecessarily hampered in their noble effort by the religiously ardent who instead can work collaboratively together to secure a successful and responsible implementation of such a policy - legally, morally and religiously!

46 PEACE IS ALL OF HUMANITY'S!

<div align="right">2013 FEB 12</div>

It is most tragic that, in this time and age, there are humans who were, and still are, born into, grow up in, and, saddest yet, died by, brutal military violence.

It may be racial strife for land and opportunities as in Myanmar, India, African nations, Or political power struggle as in Syria, Egypt, Or it may be separatist struggle for autonomy and independence as in Myanmar, Thailand, Tibet, Kashmir, The Philippines, Spain, South American countries, Turkey,

Otherwise, the militarism is due to war against the perceived expansion of influence of 'Muslim' fundamentalists who want a stricter form of Islam, such as the Taliban, Al Qaeda, Boko Haram, as in Afghanistan, Pakistan, Nigeria, Mali, Middle-East,

Tribalism, sectarianism - Shiite and Sunni in Islam, Catholics and Protestants in Christianity, etc, blood diamonds, drugs, as in the Golden Triangle, Mexico and Columbia, and elsewhere, sworn-enemies Israel and Palestine or Iran, America and South and North Korea,

So widespread, so calamitous, so sad!

But, humanity, as a whole, has a right!

The right to peace and calm, and a safe and secure existence and life!

It is a right that is not recognized, much less respected, by the political leadership of many administrations and political groups.

After all, the common victims in the violence everywhere are the meek, who for the larger part are voiceless, and where and when they do have a voice, such

voice is often too soft and too weak, usually not worth hearing to, much less appreciating its existence or its presence.

However, through all these, there had always been such voices, however feeble, however small, that seek to forward objections to the murderous bestiality by the conflicting sides. But alas, these were ignored, or put down mercilessly.

Fortunately now, the numbers from this side have grown. The voices are now more organized and louder. And more sophisticated.

From lobby groups and representations to appropriate bodies, nationally and internationally, petitions are put out for national and global civil support. Though results are yet to reach the intended level, such political- and civil-peace activism are growing at a rate that all can be proud of.

It cannot be denied that military hard- and soft- wares play a significant role in the perpetuation of domestic, neighbourly and regional violence. The annual national acquisitions of such wares in the name of defence, and so is facilitated by defence budgets, even though for a bigger part they are actually tools for offence - against own countrymen or neighbours, depending on your differing viewpoints.

One direct step in the move to reduce violence would therefore be to call for a serious decrease in defence budgets, with the indirect result of lessening corruption in defence contracts, and a lowering of military stockpiles of all sorts. The money thus saved can be better utilized for improving basic needs of the less privileged members in all nations.

The arms industrialists can redirect their expertise to the development of tools that can assist humanity mitigate and overcome the many challenges confronting him, instead of developing and selling more efficient killing and maiming machines.

Greed, at all levels, for name, riches and power, the major driving force for most, if not all, of man's sorrows and sufferings, must be recognized for its all-engulfing, destructive potency and tackled humbly and wisely, but rigorously.

From harnessing educational faculties for awareness and propagation purposes, to embracing correct values as life and work culture and ethics, these soft skills approaches have their share of correction and prevention.

Should China, Taiwan and Japan engage militarily over their disputed islands, they are only acknowledging to the world what selfish, greedy, marauding, recalcitrant miscreants they really are.

Rightly, they should be told so!

The international community's impartial assessment of flash-point situations, and forceful encouragement to the negotiating table, coupled with vigilant supervision and reminder to nations to reduce arms stockpiles can all positively impact the peace process, instead of prejudiced, selective criticism of military activities by particular nations while keeping mum on favoured others. In all these, non-partisan, apolitical, conscientious civil society has increasingly played its rightful role.

The current Tunisian administration's reversion to non-partisan technocrats to avert power struggle and mayhem from political upheaval underlines the usefulness of non-political, conscientious civil society in national administration and problem-solving.

Whether political leadership of national administrations are willing collaborators or otherwise, non-partisan, conscientious civil society will continue, more dutifully and with greater diligence, its' harmonious, constructive march in this direction to secure the cherished, elusive, much sought-after national, regional and global collective peace and well-being for people everywhere.

47 NUCLEAR OR RADIOLOGICAL, BIOLOGICAL, CHEMICAL, CONVENTIONAL,

2013 FEB 18

North Korea's latest successful underground nuclear test and South Korea's flexing of its missile muscle in response, is typical of the distrusting, hostile, and destructive world that we live in.

A world where man has neither outgrown, nor out-developed, his inherent insecurity. That, other than self, all else are hostile, out to maim, kill and destroy. An exclusive world where one has only oneself to ensure survival and continuity. That all acts by those perceived as enemies are hostile and must be responded to, in kind. That the message must be that one is just as capable of destroying as whomever else.

We stand most firmly against all manners of weaponry - nuclear or radiological, biological, chemical, conventional,

Chiefly against all things nuclear - nuclear power-stations, nuclear-powered vehicles : submarines, ships, planes,, nuclear-induced genetic engineering, and at the top of this list, nuclear warheads. All due to their undeniably-massive potential destructiveness for man and all other living things on earth, and for the environment.

Denuclearization is not, and must not be, only for those not yet in possession of nuclear warheads, power stations, vehicles,

Denuclearization is, and must be more so, for all those who are already in possession of all things nuclear - warheads, power stations, vehicles,

No nation can tell others not to develop nuclear warheads when they themselves possess huge arsenals of these warheads. No one nation can claim good,

peaceful and responsible behaviour while portraying others as rogue nations capable of willing, violent, and gross international misbehaviour. Not the US or the UK and the European Union, not Israel or Russia, not China and Japan, nor Australia.

In fact, *no nation has yet acquired such good credentials.*

To stop the development of nuclear warheads, and to make their efforts credible, nations already in possession of such warheads should demonstrate by example.

Embarking on an earnest, sincere and honest, internationally monitored, and accelerated schedule of nuclear warhead disabling and dismantling would contribute to such credibility.

Lead by example.

Be sincere and honest in this quest for a peaceful, nuclear-free world!

Unless these nations want to continue deceiving themselves that they are able to fool the world. That they are for peace, and with the mistaken, wrong, and unacceptable notion that the nuclear warheads are only for self-protection, for their own national security, and the best defence is all-out offense, so the enemies must be destroyed as completely as possible in their own lands.

Otherwise, these nuclear-armed nations do not have the right to tell others not to develop nuclear warheads. They disqualified themselves, they forfeited this right when they themselves developed, owned and deployed nuclear warheads.

Conscientious civil society that wants peace, that demands peace, and good behaviour, on the part of all those who regard themselves as leaders of their respective people and nations, looks forward to the realization of what constitutes good responsible leadership, nationally and globally.

We look at the society in North Korea. We are confident that members of the North Korean community are also peace-loving, to also have room in their hearts for the well-being of other people in the world, the closest of whom are

in South Korea, that the development of nuclear warheads is not something they want, not something in the national interest of North Korea. Neither is it in the interest of the Korean peninsula, nor in the collective interest and well-being of the whole Korean people.

That someday, North Korea and North Koreans will join the conscientious international community as an equal, dignified, peace-loving nation and people as any other.

Likewise the community of South Korea. It is quite unimaginable that there is no member of the South Korean community who is peaceful, who does not want any of the primitive and barbarous ways that are followed by some in the leadership of the day and who are present in their society. Those in South Korea who long to be united with their kinsfolk in the North. Separated most cruelly by obsession with political ideology that caused, and is still causing, heart-breaks and tears, bloodshed and death. Such obsession instigated by evil inciters with their devilish designs.

The reward for transcending past excesses, quarrels and antagonism is an unification that returns kinsfolk to kinsfolk, fathers to sons and daughters, brothers and sisters to brothers and sisters, The joys and tears of happiness of reunion will be worth it.

All the time wary of the evil ones who work tirelessly to separate kinsfolk from kinsfolk, breaking up families, sowing distrust, hatred and enmity. The conscientious world looks forward to the Day of Reunification of the Korean Peninsula, of North and South Korea, each part following its own political choice, each side not interfering with and in the other, two different systems at peace.

One united peninsula!

One peaceful, united, dignified people!

Democracy does not gain!

Communism also does not gain!

The winners will be the Korean people!

The gainers will conscientious society that wants peace and an united people!

The true beneficiary will be humanity - A singular, peaceful and conscientious plural humanity!

Thailand's reported current Chiangmai Cobra Gold multi-nation military exercise, supposedly for the advancement of common goals and collective regional security, similarly reflects the landscape of potential human barbarity toward his fellow man - exercises on nuclear, radiological, biological, chemical and conventional warfare.

Are these what man has in store for his fellow man?

Are these what modern man has to contend with today?

Of course, hands down, the most destructive is nuclear.

The leadership of all nations in the development and possession of these weapons must be grouped as Criminals against Humanity. Declassified only as and when dismantling is total and complete.

The recent eruption of the meteorite over Russia causing damage and injuries offers a good situation for human cooperation and collaboration, and positive use of conventional missiles.

From satellite tracking and targeting of the meteorite, to determining the optimum point to safely disintegrate it in the atmosphere, that would be a responsible use of satellites and conventional missiles.

All weaponry should be to secure the well-being of humanity, whoever and wherever they may be. Not the selective maiming and annihilation of groups and communities on whatever manner of prejudiced justification.

48 PAKISTANIS, WHY HAVE YOU STRAYED SO?

2013 FEB 19

It is always sad when lives are lost. More so when innocent lives of children, women and the elderly are killed needlessly, mercilessly and senselessly. They lost their lives without knowing what is it that they had done, much less knowing the reason why?

It does not matter whether the savage butcher is the one who gave the order for the drone execution, the deranged member of civil society or some ex-serviceman unable to adjust back to civilian life, some misguided militant, suicide-bomber and the like, or greedy, power-crazed political antagonist.

The barbaric crime remains the same!

The tears that flowed, the loss felt, the lives of love ones affected. All bear the same ugly hallmarks of unforgivable, primitive bestiality!

There are those non-Arabs, who know the Arabic language, the language of delivery of the religion of Islam, as though it is their native language, their mother-tongue.

Their ability to read the holy text is excellent. Similarly, their counterparts from the Arab world.

Unfortunately, their interpretation and understanding of the holy message, that become another matter altogether. If their personal conduct to others, family members included, is a reflection of their understanding and knowledge, then we know that they have traversed not the path intended for them by the holy religion of Islam.

Islam, the religion that preaches peace!

But, peace seems to be the most elusive thing that they do not know about, or understand, or perhaps, neither do they care about.

They profess that they are ardent followers of the religion: from the keeping of the goatee to the wearing of robes, supposedly mannerisms of the holy Prophet. Religious rituals are performed with the most regimented rigor.

Beyond that, many of the teachings and tenets of the religion on personal, societal, national and global relationships are, consciously or unconsciously, wilfully or otherwise, not followed - neglected and abandoned.

Islam involves complete submission to the sole Creator, the only Master, the totally Exclusive One worthy of worship!

It entails evaluation and acceptance of such submission only by Him and Him Alone!

No one, however learned or knowledgeable he thinks he is, or others think he is, is qualified or has the authority to evaluate acceptance of such submission by anyone.

To do so constitutes blasphemy, a blatant, sinful attempt at usurping the absolute authority of the ONE and ONLY.

Islam also includes not being obsessed with and idolizing anyone to the point of worshiping, that the person idolized is incapable of any wrong. The Prophet Muhammad, peace be upon him, himself most strenuously forbade such behaviour, such practice, of those closest to him. What more other humans who declared themselves his followers.

With such basics in place, those who regard themselves of the Islamic faith would do well to continually assess themselves, indulge in continuous self-scrutiny, in thoughts, words and deeds, so that all are well within the dictates of this holy religion.

Thus it is, that there should not be groupings among those who declare their faith in Islam, no sectarianism, no obsession with personalities or families, nor with ancestry, tribe or parochialism.

But alas, this unhealthy non-Islamic practice is exactly what had taken place and what is actually happening in Pakistan to the point that it is a desecrating tradition, pitting 'Muslims' against 'Muslims'.

So, mosques are not recognized as mosques if they are built by those not from one's group. 'Muslims' can be butchered by whatever means when they are not of one's own sect. Worst of all, 'Muslims' can be massacred in mosques by machine-guns, rockets, suicide bombings, often with the grossly repulsive notion that such massacre is jihad, or war in the way of Islam, that those who should lose their lives doing so are martyrs and go to heaven.

Just how sick can we be?

How much sicker can we get?

Where is the goodness and proper conduct taught, and so demanded, by Islam?

Where is the peace taught by Islam?

Sunnis, Shiites, other sects and groups, Al Qaeda, Taliban and other militants, families, tribes and communities, and nations - you are unimportant in, and to, Islam.

You are of no significance to Islam!

So, stop your sinful thoughts and reasoning.

Stop your barbarity, the very thing that Islam seek to free humanity from!

There are only Muslims, Muslims and more Muslims!

There are only those who most humbly, and most obediently, submit totally to Him and Him alone, and choose to live life in total subservience to Him, and Him alone, strictly guided by His Holy Religion through His Holy Book. Stop straying and return to the proper fold! Animosity among brothers of the same faith is nothing but the work of the devil itself. Anyone who professes Islam as his religion, humbly, sincerely and honestly, should know better.

A house of Allah is a house of Allah, whosoever built it, for the total, singular purpose of worshiping Him and Him alone, not for the commissioning of murders of brothers and sisters of the same faith, on whatever justification.

Lashkar-e-Jhangvi, the group that claimed responsibility for the February 16 market attack at Hazara town, you are no jihadists.

Likewise, all militant groups in Muslim nations - Iraq, Afghanistan, Libya, Syria, Egypt, Mali, Lebanon, Algeria, The Philippines, Indonesia,

You are not doing Islam any favour!

Realize your folly and cease your murderous ways. Reflect on Islam, the religion of peace, as you who like to call yourselves Muslims should!

49 Nuclear - Nothing Short Of A Total Ban Or A Total Embargo Will Do!

2013 Feb 20

The world's inability to rein in nuclear warhead development by Iran and North Korea betrays the impotency of current approaches. Anger, frustration, helplessness, hopelessness, impatience, growing indifference or hawkishness, the whole spectrum of human emotions in situations of this type. Seriously, the real options available fall into three groups.

Firstly, the rest of the world may join hands and bomb Iran and North Korea into smithereens. This way there will be no more Iran and Iranians, and no more North Korea and North Koreans, left to further their nuclear program and continue being stubborn and persistent pains in the side.

The results will be instantaneous, immediate, their sworn-enemies will rub their hands in glee, hooray! And, the warning goes out - any 'rogue' nation that unwisely attempts such a misadventure will meet a similar fate.

But, of course, nuclear warheads cannot and must not be used for this purpose as such an act can result in the radioactive cloud being blown into our own, or our friends', backyards. We have not yet master control of the way the wind blows, remember?

But then, who knows?

The second less violent, but not necessarily kinder, option is to impose a total embargo on Iran and North Korea, not just an ineffective economic embargo involving trading houses and financial institutions, as currently. No food, no water, no medicine, no trade, no petrol, no money, no

It is less violent, different from the instant violent death and destruction from the brute force of massive conventional missiles or nuclear explosions, or the

destructiveness and physical suffering of radioactivity. But not kinder because then death would be prolonged, coming slowly from depleting food, water, medicine, petrol, In short, they are starved to death or they are allowed to die from sicknesses.

We see that these first two options really have little chance of seeing the light of day, for the simple reason that there will never be total agreement from leaders of the global community. Otherwise, civil groups will rise and protest the sheer cruelty of both approaches.

The world has coerced, the world has threatened, and the world has bribed. All have been in vain, not borne fruit. Only awaiting the time when both these nations succeed in getting their hands on this unnecessary, unwanted, all life-threatening tool of mass destruction that the rest of us most strongly oppose.

To continue such a methodology, including via the moribund group of six, is quite frankly a sheer waste of time and resources, on nations that see their very existence threatened by so-called sworn enemies who are nuclear-armed.

There is a third option!

This is civilized. It is conscientious. The rest of the world jointly guarantee the security of both Iran and North Korea from attacks by their sworn enemies and their allies.

All currently nuclear-armed nations embarked on an immediate, accelerated disarmament of their nuclear-warheads and other weapons of mass destruction - biological, chemical,

All nations, without exception, agree to, unreservedly, irrevocably, and with total commitment, to total peace, a world without wars and military conflicts. Security will be joint, regionally and globally. The only enemy will be the criminally bad guys.

And *the vehicle to accomplish all these?*

An impartial, well-represented, strong United Nations, or some other global organization, that commands the respect of all, on account of its' fairness and its' strictness wherever, whenever and with whosoever necessary!

An organization that is free from the clutches and dictates of power blocs and imposing individual nations. A vehicle not sterile, subservient and weak as the United Nations is now, often proposing and passing grossly prejudiced resolutions, or otherwise unable to implement those agreed resolutions of quality that are not in the interests of particular nations and power blocs.

Dare we dream?

Dare we hope for this fairy-tale ending to this seemingly perpetual threat to the well-being of humanity and all other living things on earth, and the environment?

The answer is in the hands of the current and future leaderships of nations and of conscientious societies everywhere.

A nuclear-free world where the development and possession of nuclear-warheads themselves are crimes against humanity, judged, punished and enforced by an International Court of Justice of the highest integrity, commitment and the greatest impartiality. And, where scheduled migration away from nuclear power stations and nuclear-powered vehicles are national and global agendas.

A world in which captains of the arms industry awake to their inalienable and compulsory individual and collective responsibility and duty to humanity, constructively utilizing their talents, skills, creativity and innovation, in the development and production of constructive tools and machines that can assist man in meeting the challenges in his life here on earth, especially the ravages of severe climatic and natural upheavals, and diseases.

Instead of the development and production of increasingly more efficient killing and destructive weaponry, and making money on the blood and destruction, sufferings and heart-breaks, and blood and tears of people everywhere, as is being done now!

50 Welcome On Board, Madam President!

South Korea admits its' new and first lady president amid much fanfare and the world famous gangnam.

Congratulations!

President Park Geun-Hye's declared trust-building with North Korea is, at the very least, admirable. Her hawkishness, constructively harnessed and properly directed, can bring about many positive development for her people and the rest of the world.

Reining in greedy, corrupt industrialists and officials, party or otherwise, and not falling into the corruption trap herself, much like her past counterparts in the Philippines, Bangladesh, Pakistan,, putting in place economic policies that drive modest, well-paced, sustainable activities alongside thrift, non-extravagance and non-wastage, and taking valuable lessons from the experience of the European Union, These will be humble, wise doctrines to guide good governance now, in South Korea, as anywhere else, and at any time.

Unlike the selfish, greedy economic pursuits of China, India, Malaysia, Nations of the West,, that result in millions of unoccupied apartments, off-the-scale smog that requires ban on family barbecues and alternate-day driving to reduce, and other types of pollution, new-found-wealth driven arrogance and military hawkishness,

Ugly. ultra-greedy, corrupt economic policies, the pursuit of which as if there is no tomorrow!

Only now trying futilely to mitigate the possibly insurmountable damages done!

Her biggest challenges will not be the slowing economic growth, soaring welfare costs, the rapidly growing ageing population, and As she herself is well aware, her avowed zero tolerance to North Korea's provocation and her demanded abandonment of its' nuclear ambitions.

Indeed, North Korea's recent nuclear test is not only a challenge to the survival and future of the Korean people, but together with the nuclear arsenals of nuclear-armed nations, of the whole of humanity! The biggest victim need not be North Korea herself, but the whole Korean peninsula, North and South together, and Asia and Asians, and

Both the North's Kim Jong-Un and the South's Park Geun-Hye must realize that they are NOT enemies of each other, but kinsfolk - young countryman and senior countrywoman. That, North Koreans and South Koreans, they are but one and the same people. That the real enemies of the Korean people are those who diligently,

desperately, and devilishly worked overtime to divide the Korean people in furtherance of their own selfish, greedy, personal and supposedly national agendas - America, the EU, China, Japan, Russia,

That political ideologies, much like constitutions, and amendments to constitutions, are there to serve people and not the other way round, people deforming their lives trying to fit in, to be in line with these instruments.

That there is no perfect political system on earth, ever.

That time will modify political ideologies to suit particular needs of the people of any nation - socialist elements will creep into the democracy of South Korea, such as in its attempt to look after the welfare of its destitute and its aged. Likewise, pure communism will not last in North Korea, just as it has given way in Russia, as in China with its' massive embrace of greedy capitalism, and as in the rest of the communist world.

So, ***nobody should really be too worried here, about political ideologies. These are merely horribly weak excuses for the evil designs of the less creative, and the grossly incompetent!***

The challenge of all challenges to South Korea's President Park Geun-Hye is to declare, unreservedly and irrevocably, to defend North Korea in totality against any attack by America, the European Union and their allies.

At the same time, the challenge of all challenges to North Korea's Leader Kim Jung-Il is to feel sufficiently assured and safe from the protection of South Korea to the point that he can abandon his nuclear ambitions.

Added to the successful meeting of these challenges of challenges, will be the glory of an unified Korean Peninsula and an united Korean people.

The joys of such an unity and the immense constructive possibilities and opportunities that accompany it, should more than compensate each leader and each half of the Korean peninsula and people, and whatever loss of face, ego or whatever else.

Not so that they can then go on to oppress other less economically and technologically capable and aggressive people. Not so that they can impose any imperialistic and superior race mentality, or bully others with their combined military prowess of any kind.

But, just so that a new president of the kinder gender can convince her younger, more impulsive counterpart in the North, and bring collectively with them a new dawn and a new beginning for the Korean peninsula, a new hope for their collective people - the whole Korean people, and thereon a new chapter in the history of Asia and the rest of the world.

Of course President Park Geun-Hye will have the added task of persuading all the nuclear-armed allies of her South Korea, and others, that they have to denuclearize by dismantling and disabling all their nuclear warheads. That's because nuclear danger to the people and nation of South Korea is not just

from the nuclear program of Kim Jung-Il's North Korea, but also the nuclear arsenals of all currently nuclear-armed nations.

May this auspicious recognition of the equality and capability of the gentler gender in South Korea bring with it a renewed hope for peace in the Korean peninsula and unity of the Korean people, as an important step towards peace and well-being for all of humanity!

51 NON-PARTY CONSCIENTIOUS REPRESENTATION - IT CAN BE DONE, ITALY HAS SHOWN!

2013 FEB 27

The 5-Star Movement of comedian-turned-politician Beppe Grillo's sterling performance in Italy's elections underlines the increasing role of non-party politicians everywhere.

While non-party politicians, also referred to as 'independents', have been around for a long time now, deteriorating performance by party politicians in leading the administration of nations, drive non-party conscientious members of society to offer themselves as viable alternative leaders.

More often than not, people and nations get misled, not led, by crooked party-politician administrators and their civil counterparts, alongside greedy, immoral business people.

These are the kleptocrats - thieves, robbers and plunderers in administrations of nations of the world, who seek name, status, riches and assets, at the expense of the very people they purport to administer.

And, *THEY ARE EVERYWHERE!*

Some became multi-billionaires after holding high office. Others were businessmen who bend and abuse laws to facilitate their crooked businesses, aided by willing equally-crooked public officials, reaping billions in the process, then became politicians who hold the highest offices in their nations.

All the while, shamelessly and dishonourably, indulging in the most repulsive of debauchery, including with under-aged girls and chambermaids, together with their criminal-accomplices-in-sins, who themselves hold high offices in public, international and global institutions.

So it is, in the United States, Italy and elsewhere in the European Union, as it is in Asia and Africa, in fact everywhere in the world.

The current mountain of woes everywhere. social, economic, religious and political, is a direct result of the leadership-mislead of these kleptocrats.

In their pathetic attempts at remaining popular, some also resort to non- and anti-leadership, pandering to every whim and fancy of select segments of populations, in their desperate effort to cling on to power instead of morally leading people and nation to new levels of real quality.

But, ***CONSCIENTIOUSNESS HAS NOT FAILED HUMANITY!***

Members of societies everywhere rediscover their moral side, remembering ethics and virtues, and strengthened and emboldened by these, they voice out, they step forward, they act and they offer themselves as representation of, and for, their people.

And today, we witnessed this taking place at such a commendable scale in Italy.

IT IS AUSPICIOUS!

It marks the coming of age of a movement started long ago by civil rights activists hungry for correct leadership that will produce real quality lives for people everywhere!

Today, positive activism is alive as never before. Constructive activism grows stronger by the day. *The time will come when nationally- and globally-networked, non-party, conscientious activists lead nations and the world, bringing in their path the kind of society, the type of world, that we singly want. that we collectively aspire for, and which we are determined to achieve!*

52 THIS IS WAR!
MALAYSIA'S SOVEREIGNTY VIOLATED AND INVADED! NIP IT FAST BEFORE IT ESCALATES FURTHER!

2013 MAC 04

We mourn together with, and extend our sincerest condolences to, the families of all our armed-forces and the police who sacrificed their lives and suffered injuries in the defence of our beloved nation.

This is war, most wickedly, and most maliciously, disguised as a claim to Malaysia's legitimate territory.

The administration must wise-up and treat it as so. While a trusting nature should not be seen as a weakness, goodwill without caution only causes unnecessary and wasteful deaths and sufferings for our people.

How many more lives must be lost, how many more able-bodied must be injured, some critically, before we wake up, before we act more decisively and more appropriately?

Lahad Datu involves the armed nationals of another nation.

In its barest form, it is armed intrusion by one nation into another sovereign nation.

A hostile act, an act of war by one nation against another, whether such an aggression is publicly and officially sanctioned or otherwise.

Whether publicly, there has been rebuke!

The Philippines leadership should be told so in the clearest terms. The situation should not be allowed to deteriorate further till there are more deaths, more

critically injured, more locals from their ethnicities who get sucked in, many willingly and actually prepared for it, before we come to our senses and awake to the reality of what is really happening.

If there had been collaboration from anyone on the Malaysian side, whichever half of the political divide he may be sitting in, then the reward for such betrayal, such treason of people and nation, is death by hanging from the nearest tree.

Conscientious society wishes to reiterate, most strongly, its absolute resistance to violation of our beloved nation's sovereignty, in whatever form, under whatever guise.

We would like to see peaceful resolution to the matter, but not at all costs.

Asean solidarity and collective security can be urgently requested, with a peace-keeping multi-national force to keep the peace while the Philippines are told to evacuate their citizens the soonest possible. We hope that it will not come to this - otherwise it would be war.

This is unlike the previous communist insurgency. It is more like the Indonesian Confrontation! A hostile act of war to take part of our nation. Muslims and fellow Muslims is non-existent here. It is just greed, for status and land. Nothing more, nothing beyond.

The Malaysian leadership were fooled by the supposed peace accord between the armed intruders with the Philippines administration. It is a move to removal the need to engage with the Philippines armed forces so that they can focus on dealing with the Malaysian armed forces. All this while, we extend our understanding, we offer our Muslim brotherhood.

Wake up, act most decisively and most strongly. Otherwise peaceful Malaysia may be peaceful no more!

53 Nuclear - the End of Humanity!

2013 Mac 12

The scientist-discoverers of nuclear fission and fusion, and the colossal amount of energy involved, would not have, in the remotest corners of their minds, imagined that their discoveries, like so many other scientific findings, hold the highest possibilities of bringing the end to humanity.

Had it been known, perhaps they would not have proceeded to initiate and investigate such physical mysteries!

The peace- and life-loving among them probably turned in their graves at the uses that hold danger and destructiveness of such magnitude that man is putting their knowledge to, endangering not only humanity, but also all other life-forms, and mother earth herself.

And, *the danger and destructiveness are only being minutely experienced -*

the real reality is yet to come!

Yet the leadership of so many nations unwisely and impatiently get on this very same bandwagon that is most certain to hasten and bring the end to mankind.

This second anniversary of the Fukushima nuclear power station mishap with its accompanying nuclear meltdown, witnessed the continuing mopping and cleaning up of the resultant wreckage and radioactive contamination - a job that is being attempted with grossly limited, positive outcome.

The future will never be the same!

Two years down the road, contamination had travelled to the other side of the Pacific, as well as spread through the local ground. And, this is only a rough estimation of the extent of the spread of the contamination!

The sum total of the damage to people, land and other living things, at the present and in the future, remains an insurmountable task, even just to approximate!

The affected and displaced inhabitants cry criminal political and administrative neglect!

For all our scientific and engineering advancement and prowess, we are all too aware of our own severe limitations, and the imperfections of our engineering and technological creations.

Nations do not need nuclear warheads to defend themselves. Conventional missiles already carry more than sufficient destructive firepower to blow to smithereens any foe foolish enough to attempt.

Nuclear warheads and their radioactive fall-outs are more for total destruction of others, and depending on which way the wind blows, and other climatic conditions and natural forces, may well also hit ourselves and our friends.

And, who is to know that radioactive wastes are not being dumped in the deep oceans by nuclear-powered submarines and other vessels?

The deep-sea whales and other inhabitants, that surface to live out their last hours on the shores and the beaches, should be tested for radioactivity, if not for anything else, at least to confirm for ourselves that such a heinous crime is not being perpetuated by the sick, immorally and criminally irresponsible.

Environmentalists, oceanographers, nature lovers and other activists, and the socially conscious and responsible others - please take note!

Corporate social responsibility of business captains in the energy, arms and transportation sectors need to extend into a consideration of rapid, scheduled migration away from nuclear into non-nuclear alternatives that do not leave other endangering footprints for man, as well as for other living creatures and the environment.

Nuclear-armed nations disqualified themselves from talking about non-nuclearization and denuclearization to those nations bent on developing nuclear weapons!

Where nuclear is concerned, the pot cannot call the kettle black - the nuclear-armed cannot tell the non-nuclear-armed that they cannot develop nuclear weapons, or that they have to remain non-nuclear-armed, or that they have to denuclearize!

Those leaderships who have humbly, wisely and far-sightedly accelerated their dismantling and decommissioning of their nuclear arsenal and nuclear power stations deserve praise!

Expanding their constructive leadership by shortening the schedule for their total nuclear disarmament, and total migration away from nuclear-power energy generation and vehicles, will serve to confirm their collective moral responsibility towards, and goodwill for, all of humanity, and earn them the right to stress on non-nuclearization and denuclearization to one and all!

The leadership of nations not yet in possession of nuclear warheads who arrogantly, stubbornly and foolishly insist on developing nuclear weapons, are telling the world that they want total ex-communication and total embargo.

Total ex-communication and total embargo, not just economic embargo, will mean none of their leaders and common citizens can get on any public transport of, and set foot in, the rest of the world, that their leaders and citizens will be evicted from whatever commercial positions they may be occupying in whichever country except their own, and deported back, that all legally- constituted and instituted commercial entities and international agreements concerning whatever matter, with the rest of the world, cease unconditionally and indefinitely,

And in times of severe natural disasters, from snow blizzards, storms and flooding, drought, earthquakes, volcano eruptions,, **THEY ARE ON THEIR OWN!**

Except of course their rogue cohorts.

The rest of the world cannot, and do not, care anymore!

THE REST OF THE WORLD MUST NOT CARE ANY MORE!

Any leadership, any nation, any people, that disregards the collective well-being of humanity and all other creatures, that holds the world and her people to nuclear- blackmail and ransom, forfeits the right to any form of sympathy, compassion and assistance, in times of extreme need and AT ALL TIMES!

And, when your cohorts similarly misbehave, they get the same kind of total-ex-communication, total-embargo and total-cold-shoulder treatment.

So, North Korea, Iran and the rest with similar thinking lines - be forewarned.

Global nuclear zero requires the total awareness and total commitment of the leadership and all other parties in all nations in the areas of energy production, vehicle fuel and weaponry!

Nuclear will spell the end for all of us!

We do not need it!

We have safer alternatives!

The earlier we are rid of it, the earlier the safer and more secure it will be for all of us, individually and collectively!

Let us all humbly learn!

And, LET US ALL ACT ON WHAT WE HAVE HUMBLY LEARNT!

54 China - Rein In Your Horses!

2013 Mac 20

Hello China!

Some have described you as the sleeping giant who has awakened. Others called you the slumbering elephant that has stirred. Whichever way, you are big and you consume enormously! Be it food for your people, or commodities and other raw materials for your industries.

Being huge, you have been prone to bullying in some instances, and trampling on others at other times!

Fortunately, there are those of us who managed to remain sober and maintain our sanity and conscientiousness, our little measures of culture, civility and civilization.

We diligently follow your growth and your conduct, nationally, regionally and globally.

Quite frankly, we are frequently appalled and saddened by your profound greed and extreme selfishness, and your devil-may-care drive to industrialize at any and all costs, and in the shortest time possible – all quite typical of the ultra-greedy!

We voice out humbly, sincerely and honestly and with the strength from true love for, and total concern with, the collective well-being, safety and security of all of humanity, and the world as a whole.

We hope that you, with your big heart and your equally big ears, have room for our soft, little words, and share our enthusiasm for the sustainable livelihood and welfare of the people of other lands!

Now that your once-in-a decade power transition of top leaders is accomplished, and the task of leading people and nation gets underway, your newly chosen President Xi Jin Ping has declared your continuing realization of the great renaissance of the Chinese nation and the Chinese dream - a vision of stronger military and ever-higher living standards.

Vision statements at the onset of new leaderships are customary and beneficial to drive leadership, people and nation.

Leadership, however, must lead towards goodness, and greater goodness!

This, of course, necessitates a sound understanding of what constitutes goodness.

Greed and its' promotion certainly do not fall under this heading!

Neither do gross selfishness, unscrupulousness and repulsive dishonesty!

Nor a flagrant disregard for the welfare of others, especially those lesser developed, lesser endowed than us!

The uncontrolled all-out pursuit of greed results in a whole host of negatives - off-the-scale polluted air that does not support life, and reduces visibility and affects land, sea and air transport;
material drunkenness and wasteful consumerism;
deceits, lies, gross dishonesty and all manners of commercial fraud;
forced live-organ harvest;
human trade and modern-day slavery;
land grab;
tainted milk-powder and medicinal products, substandard food and other goods;
collapsed buildings, highways and tunnels;
......... !

It is a very long list of misdemeanours!

As usual, greater riches bring greater insecurity!

So, now there is this need to boost security and increase defence spending to make the military stronger so that it can 'win battles' ?

And, **the Great Army of The People's Republic of China is still not yet sufficiently strong???**

With all these against the declared backdrop of not pursuing hegemony???

All the while claiming as your own, the sea that carries your national namesake???

Your economic model is being exported to nations all around the world that get seduced by the material 'success' of this big giant that has awakened. Unknowing nations that will similarly suffer irreparable environmental destruction and pollution, unscrupulousness, moral decay and immorality, wanton wastage and gross extravagance.

For a nation with such a massive GDP, a targeted 7.5% yearly increase for the next decade is tremendous by any consideration.

Which nation is going to suffer shrinkage just so that you can achieve your targeted growth?

Or, is it possible that there can be simultaneous, expansionary economies worldwide?

Most probably those nations that work hand-in-glove with cross-border kleptocrates who continue to deceive their people and others with such immoral transnational trade-offs!

Together with the disruptive upheaval in prices of commodities and raw materials that will definitely and severely upset the economies of the smaller, weaker nations that are more in need with their small economic plans?

Your population control through your one-family-one child policy is better served by a one-child-per-individual-per-lifetime rule.

Like your other arms developing, producing and selling cohorts who profit from the suffering, blood, destruction and death of others, you rejoice at conflicts in nations for they present excellent opportunities for you to peddle your wares of suffering, maiming and death.

Likewise, you disqualified yourself from asking others not to develop nuclear weapons when you yourself, like your fellow nuclear-criminals, continue to maintain and upgrade your nuclear arsenal!

Your relationship with your daughter Taiwan - nothing will ever change this relationship - despite all the strenuous, evil effort of those determined to undermine families of nations for their own selfish ends, much like North and South Korea, North and South Sudan, !

You should know better!

Do not do unto North and South Korea what others are doing to you and Taiwan! There are those in Taiwan who too wants to reunite with the motherland.

Work with them tirelessly and fruition will come!

Do not give them cause to produce and position their Yun Feng middle-range missiles at your military sites.

Not that you are a least bit afraid.

May the commendable values taught by your great teacher Confucius figure strongly in the renaissance that your current crop of leaders proclaimed, so that the ever-higher living standards envisioned is not founded totally on materialism and technology, that will quickly degenerate into abusive debauchery, but the truer, more meaningful moral facets of life!

Or, *is there no more place for Confucianism and its' attending values in modern-day China?*

Only you can determine what you and your people will be - a moralistic, cultured, conscientious people rich in humanitarianism, or a nation of modern day greedy barbarians in business suits who travel about in business jets, showing primitive savagery at the slightest provocation, assisted by sophisticated satellites and guided missiles systems!

55 Syria - Fallen Prey Of International-Community-Vulturous-Predators!

2013 MAC 25

Syria has fallen, in the same manner as Pakistan, Afghanistan, Iraq, Libya,, prey-victims of greedy, marauding, blood-sucking, vulturous- predator members of the international community, whose grossly and repulsively selfish and greedy economic and political hegemonies manifest themselves in the perpetual destructive conflicts of weaker nations!

Democratically-elected administrations are not given due recognition, much less respected, and the cordial relations they deserve, if, and when, they do not stand on the same side of devious, vested interests!

Thus, plans and strategies are hatched to destabilize and cause the downfall of such administrations, and in their place are raised puppets willing to forego national and people self-respect, dignity and interests, never mind that these administrations have been elected democratically.

It is neither important nor does it warrant any care that the majority of the people in these nations want such administrations. They do not want, nor are they willing, to be running-dogs, or they maintain links with unfriendly and so undesirable, sworn-enemy nations and leaderships, thus they do not hold promise and they must go.

At any, and all, cost!

No matter that in the process, people are maimed, or killed, properties and heritage are burnt and destroyed, kinsmen are pitted against kinsmen, and economies devastated.

Military conflicts are best opportunities for the widest array of objectives - economic, military, political - the whole works!

What better time than in military conflicts in some faraway land to deplete that stockpile of obsolete arms, those batteries of low-technology guided missiles, to test, in real battle conditions, those fighter jets and land assault vehicles, ……...

And as a bonus, the putting up of new puppet administrations that are easily kept under the thumb, who will agree to that host of detrimental agendas, including the purchase of new arms to strengthen future national security, and the collection of other hegemonic objectives.

Its easy, because these new puppet administrations, basking in their phony euphoria, will be too emotionally confused to be able to figure out sensibly what is truly taking place.

After all, they have been so easily misled all this while.

So these vulturous-predator nations of the international community, who not only feed on live preys but also their carrions, peddle their tools of untold sufferings and death, and reap their profits on the blood, suffering and death of other humans. It is all alright, as long as all these do not take place in their backyards.

And, these are the very people who scream, ***"Democracy, Nothing else"!***

So much for democracy!

It is just a rotten, murderous tool for the propagation of evil, as these nations so generously refuse to let the rest of us forget!

So, the same script gets repeatedly written for nation after unfortunate nation.

Most tragically, they get acted out most immorally, with utter impunity, seemingly unstoppable

How else can these non-creative people get on with their lives and their non-innovative strategies for their economic, political and military hegemony?

After several years of failure to overcome local resistance, as in Afghanistan and the Taliban, they make their escape plans and send out feelers for ceasefire and power-sharing with their earlier sworn-enemy combatants who now suddenly hold the most promising potential to be future partners.

Such is the fortune, or is it the misfortune, of the Taliban in Afghanistan and elsewhere!

Most probably, this gets extended to Al Qaeda in the not-so-distant future!

Most certainly, all these outreach come with the accompaniment of the utmost insincerity and the most disgusting dishonesty!

Oh, the sickening pain gets more and more unbearable!

In the face of such destructive skilfulness, such devilish expertise, do we, the conscientious meek who are present in all nations, stand a chance?

Those of us who are not, and refuse to be, on their side of the good-evil divide?

Can we, are we, capable of turning the tables?

Can we put a spanner in their works of evil, of blood-letting and human suffering and death?

We would think so!

We believe so!

And, we voice and work most diligently for it to be so!

So, we propagate non-party, conscientious activism everywhere, on all issues that impact humanity, singly and collectively.

There has been encouraging, varying degrees of success in different nations. Keeping at it longer, the success should become more frequent, more widespread, and on a wider range of issues.

Non-party conscientious activists will be part and parcel of national administrations the world over, as many already are, and conscientious opinions will be brought down to bear on policy-makers and implementers.

To prevent another Syria, another Iraq, or Pakistan and Afghanistan, with their daily murderous places-of-worship, road-side and suicide bombings, non-party conscientious activists and members of society must take on greater leadership roles in their respective nations, enjoin globally and employ greater global collaboration and cooperation.

The determination to be more productive in this noble effort will bring to fruit the constructive, civilized peace that we all seek!

Let there not be another Syria, another Iraq, another Pakistan, another Afghanistan, another,.........

56 BELIEVERS - ACT THY FAITH!

All religions teach goodness - virtues, ethics, morals, humility, selflessness and unselfishness, consideration and fairness, non-violence and peace, love for life, self and others, benevolence and magnanimity,

When a human being professes a belief in a particular faith, that proclamation comes with dictates and rules, many non-violable, and a binding admission to adhere to, and lead life in accordance with, the teachings of that religion, obligations and responsibilities to self, family and congregation, and others not of the same faith, as well as other living things and the environment!

All these to ensure that one's life on earth is lived well, and meaningfully to self and others, and perhaps salvation in the hereafter.

Of course, **for believers of monotheism, the authority to decide the last is the absolute domain of the one and only Creator, Master and Lord of all!**

Merely declaring a belief in a particular religion and then expecting to go to heaven without fulfilling all obligations demanded by it, and violating its' dictates at every twist and turn to boot, is merely blind, wishful thinking.

That said, **a look at the current world confirms that we have never digressed, infringed, violated and desecrated religions more today than ever in the history of man!**

We boast of putting man on the moon, of space stations and highly sophisticated satellites, of space travel and inhabiting other planets, of advancement in that many frontiers of science and technology, of nano science and particle physics, of

Yet we failed most miserably with ourselves, and our personal and public conduct, within our own, and with outside communities, often with the greatest neglect of the interests and well-being of other living beings in the loathsome pursuit of our disgusting, ravenous greed!

Our ego and pomposity, selfishness and blood-tainted greed, primitive savagery and murderous barbarity, bigotry, all need off-the-scale negative superlatives to describe adequately and accurately!

So, we destroy the basic moral fibres of our societies, choosing and chasing lives of debauchery, flagrant immorality and sins, bending, disregarding and blasphemously violating both the divine guidelines and doctrines enshrined in religions, and the rules and laws that we ourselves good-intentionally set up.

In the name of survival, we encroach on others' lands, we misbehave with their women- and men- folks, and we spark racial and religious clashes that spread easily like wildfires.

We destroy life-sustaining forests, mercilessly and voraciously plundering their timber and other resources, destroying life- giving and sustaining green-lungs and water-catchment areas, and inundate vast areas for our dams, and build humanity-and-all-other-life-forms-threatening nuclear power stations, to meet our insatiable, endless and limitless gluttony for our energy needs, all in the sinful name of 'development'.

We build apartments that get higher and higher, trying very hard to touch the clouds, never mind that in the process, material supply shortages are created and prices of commodities shoot up sky-high, adversely affecting others, and because, driven by our uncontrollable, disgusting greed, too many were built too fast, with most priced beyond the reach of the common man and woman, millions of units, though sold, remain unoccupied.

We flood the world with our cheap products, due to economy of scale made possible by our obscenely, super-large, cheap workforce, as if we are the only nation and the only people who matter, and only we can and should survive and live.

We bend and outrage laws to grow our often monopolistic businesses and take excessive profits, always backed by irresponsible, equally greedy and immoral kleptocratic politicians and public administrators, so that we can accumulate our lowly, indecent billions.

Capitalized by our ill-gotten wealth, we then proceed to run and occupy the highest positions of nations, all the while continuing in the indulgence of our sinful debauchery, eagerly accompanied by other high-ranking officials of international and global institutions, while wastefully misleading people and nations into financial ruins and bankruptcies.

We murder, now more widespread and with greater impunity, by our bombs, snipers and drones, small children, women and old folks regardless, and demand adherence to Comprehensive Test Ban Treaty to prevent others from continuing their attempts at developing nuclear warheads, while we ourselves hypocritically maintain our huge nuclear arsenals and allocate billions in defence budgets to modernize our nuclear missile systems, these being our twisted ideas of achieving global nuclear zero.

We inherit crazy, ego-maniacal, childish, totally irresponsible Great Leaders solely by virtue of lineage, who unspeakably endanger people and nations by declaring war on our own kinsmen who choose a different political system, driven by hegemonic instigation by evil provocateurs.

We cohort with our greedy, immoral arms industrialists in the development, production and sale of more and more efficient, murderous killing tools and machines. And we call that defence!

We initiate Movement of Moderates but we host annual International Defence Exhibitions and Shows, which are really a promotion of peddlers of sufferings, maiming and death, who reap their blood-tainted profits on such maiming, sufferings, blood and death of other unfortunate human beings.

To ensure a ready market for the depletion of old, outdated arms stocks, and the sale of recently developed ones, we sow, fan and add fuel to, internal armed conflicts in other people's lands, on account of political-ideology differences,

tribalism, sectarianism, you-name-it, of regimes who to dare challenge us, and who choose and follow ideologies different from our own.

Never mind that our actions result in unstoppable, perpetual daily bombings and destruction in public places and places of worship, and sufferings and death of people of those lands, and that kinsfolk have been, and are being pitted, against kinsfolk, as in countries of the Middle East, China and Taiwan, South and North Korea,

When we are seemingly challenged, we sign pacts with our hegemonic proxies for military action at the slightest provocation, which provocations are unilaterally defined by us, and we fly our sophisticated fighter crafts low over their territories in a provocative, bestial show of primitive, barbaric force, challenging the supposed challenger to initiate a military response.

We violently persecute others on account of their ancestral and religious differences, even though just some time in the not so distant past, we ourselves were so persecuted and brutally murdered - in gas chambers of concentration camps, and we disallow these others an existence of dignity, liberty and security as we demand for our own through our Basic Law of Dignity and Liberty.

Such is the case with Israel and Palestine!!!

We demand the right to graphically represent and make movies and videos of founders of religions and use names from others' religion in our own, citing media, personal, artistic and religious freedom, disregarding the sensitivities of others and their discomfort.

And, **we think that all these are good for the propagation of our own religion!**

We forget that our religion has its' dignity and that all these are nothing more than unforgivable affronts on our own religion!

We egoistically stand in the way of approaches beneficial to mankind, and blindly misled by our own orthodox religious bigotry, as in family planning

via contraceptives in the Philippines, removal of miscarried foetus in Ireland, and total disrespect and denial of opportunities for women in many Muslim nations.

Our greed, deceits, dishonesty, disloyalty to spouse and God, brutality to fellow human beings and animals, sunk to record lows, and those among us who practiced professions lost the meanings of the term along the way of their gluttonous pursuit of gross material drunkenness.

Such is our hegemonies - personal, political, economic, military, ……..

Our encroachments, our violations, our desecrations of our religions!

And, **WE ARE SO PROUD OF THEM!**

57 North and South Korea, Taiwan and China, Middle-Eastern and African Nations, and the Rest of the World - Beware the Evil Spin Masters!

2013 Apr 08

North Korea and North Koreans should never attack South Korea and South Koreans. Likewise, daughter Taiwan and Taiwanese, and motherland China and mainland Chinese, countrymen nationals of Middle-Eastern and African nations, South Americans and the rest of the world.

Doing so would be naively and foolishly falling into the trap of the evil spin masters. Sworn evil-doers determined to stand on the wrong side of the good-

evil divide, and be sinful. Ever-ready to spill blood and inflict suffering and death, sinisterly pitting kinsmen, countrymen and neighbours against each other.

In the process reaping blood-tainted, immoral, unforgivable profits from their arms trade, and pushing their devilish economic, political and military hegemonies.

All through the abusive execution of their wicked craft, spinning, and sowing discord, and fanning and fueling violent armed conflicts, capitalizing on tribalism and differences in ancestry, sectarianism and differences in religious beliefs and approaches, political ideology - democracy, socialism and communism, natural resources, strategic advantages,

They scream democracy, as if it is the only system that can and should work for all nations, all people!

But that too comes with a caveat - the regime that is democratically elected must be to their liking, ever-ready, ever-willing puppets, cohorts always at their beck and call.

Otherwise, it will suffer a similar fate to those courageous enough to resist being their puppets, or worse still, opposers of their hegemonic intentions.

The world has witnessed the increasingly large number of such regimes and nations that had been turned into unstoppable, perpetual blood-baths, with their daily bombings, suicide and otherwise, *and fertile, growing* markets for outdated and newly developed weaponry.

Of course, nations with childish, ego-maniacal, descended leadership who does not have the slightest idea what responsibility to people and nation is, as in North Korea, do make the job easier.

The conscientious in such nations, the common citizenry and those in their armed forces, should not remain quiet while people and nation are exposed to the unnecessary dangers of military conflict, more so with their own kinsfolk, members of their own families.

Unification of peninsulas with the same people, daughter-island and mother-mainland, and divided manipulated-nations, should be the paramount and only objective of one and the same people.

Leadership by lineage is never a good means of acquiring good leadership to helm national administrations. Humble talents with good grounding in virtues, ethics and morals, will serve people and nations better as leaders, anytime and anywhere.

North Koreans must wake up, and be wise and brave enough to discard that leadership inheritance which is now endangering, to the highest degree, people and nation, and putting paid to the hopes and aspirations of millions of the Korean and other well-meaning people, who pray they will live to see the Day of Reunification of the Korean Peninsula!

Likewise all the other victim-nations of the evil spin-doctors - Taiwan and China, North and South Sudan,

When East and West Germany can be united, there is no moral and good reason why any other divided nation and people cannot be similarly, and constructively become a harmonious one!

Not so that it can become stronger and pushes its hegemonic intentions. Certainly not so that it can intimidate, bully and swallow other people and nations.

Hope lies in the hands of the conscientious of all nations, including those of the manipulators and spinners, to bring to bear the moral aspirations of good governance, and responsible national and international behaviour.

That differences should not escalate into armed conflicts, but speedily resolved through constructive deliberations.

That armed conflicts already raging should not be further aggravated by continued manipulation and spinning, or the shipment of military advisers, missile batteries and other arms.

That the murderous slaughter through rockets, fighter jets and drones, of women, children and old folks, be stopped, soonest possible.

That unsuitable, irresponsible administrations and their leaderships be changed at the ballot box, minus the vote-buying via monetary give-outs, offers of positions, land-titles and other corrupt and wrong practices.

The need to stop economic, political and military hegemonies by any party and nation has never been greater.

It is the pursuit of such hegemonies that peoples and nations are thrown into turmoil, destruction, suffering and death, *mercilessly and barbarically, inflicted daily on the innocent masses, and unstoppable killings perpetuated endlessly.*

Conscientious, impartial, non-party representatives from society hold the key to good governance in all nations, and honest, responsible administrations of people and nations.

The role is cleat for a well-governed, constructive world that can deliver the good behaviour and peace that man so thirst after!

58 NORTH KOREA CELEBRATES ITS' ANNIVERSARY, AND AMERICA AND CHINA HATCH

<div align="right">2013 APR 16</div>

North Korea celebration of its' founder, Kim Il-Sung's Day of the Sun, is, most sadly, overshadowed by the gross irresponsible misbehaviour of its' current leader Kim Jong-un, confirming for the world the definite inappropriateness of family dynasties leading national administrations.

Responsibility of the leader of any nation extends beyond own people and nation, onto neighbouring people and surrounding nations, and thence to the rest of the world.

The totally unacceptable, recalcitrance and criminality of the young Kim's leadership pose a grave danger not only to the North Korean people and nation, and immediate South Korea and its people, but also the rest of Asia and the world. He is, most surely, not suitable material for leadership, anywhere in the world, under any circumstance!

With utmost certainty, there are those in North Korean society, and the North Korean Army, who are uncomfortable with, and opposed to, such vagrant, bellicose conduct, as well as to such senseless subservience to a family dynasty. While they may be few and far in between, the conscientious world, nevertheless, looks forward to the day when this presently small and inconspicuous group grows to become sufficiently impactful, to bring about constructive, positive change for the Northern half of the Korean peninsula, and the rest of the world as a whole.

So, on this day that North Korea celebrates its' Day of the Sun, conscientious society of the world registers its' unwavering aspiration for regime and systems change by conscientious North Koreans - civilians and in the armed forces

alike. And, we know, conscientious South Koreans and the South Korean nation are with us.

Meanwhile, while North Korea and North Koreans celebrate their Festival of Flowers, and the conscientious among them grapple with when is the best time to correct national mistakes, America and China launch their little twosome to hamper progress in the North's development of credible nuclear warheads.

Not that these two nations, morally or legally, have the right to such righteousness!

They, long ago, violated and forfeited such rights, and simultaneously endorsed their criminality by their own development and possession of such nuclear warheads.

So, we have two nuclear-criminally-guilty nations trying to hatch a plan to prevent North Korea, and, perhaps we may include, Iran, and other similarly-aspiring nations, from joining their ranks.

International treaties, like the recently concluded Arms Trade Treaty or the Non-nuclear Proliferation Pact of the past, are merely debates and passing of resolutions that are only as good as the willingness and the commitment to rectify meaningfully, and definitely, the spirit and the substance of such treaties, not the glamour and fanfare of debates and the passing of resolutions that never harbour any real hope of seeing the light of day!

Otherwise, it will be another colourful instance and another expert exercise in the wasting of national and international resources, finishing, as it does so frequently, as just another day for the boys!

No human, not any other living creature, deserves the catastrophic force of a nuclear warhead, much less the devastatingly destructive, painful sufferings that a radioactive fallout from such a warhead generates.

That such a simple scenario can escape the mental vision of third millennium man is most surprising, given the exhorted exhilaration of modern day technological advances.

Perhaps it is not that such a depressing scenario never passes through the minds of the leaderships of the nuclear-armed and nuclear-warhead-aspiring nations. It is just that they prefer to let their primitive savagery and bestial barbarity rule their hearts and their minds, and drive their international behaviour and hegemony. That such a lowly lust gives them the gratification that they otherwise would never have been able to experience.

Humanity must come to the stage when the mere possession of nuclear arsenals in itself constitutes a Crime Against Humanity, and the leadership of such nations be found guilty of, branded and punished as Criminals Against Humanity!

Can we ever reach this level of human conscientiousness?

This is the only way forward for humanity, other living things and the environment!

Global nuclear zero has several inalienable components. The total absence of nuclear warheads is one!

59 THE DAY PRESIDENT BARACK OBAMA NUKED HIMSELF!

2013 APR 23

The Office of the President of the United States of America is one of the most powerful, if not The most powerful, Office, on earth. It can assist or it can destroy nations and people, all at the command of the President, either by America herself, or, more frequently, with the willing cooperation and collaboration of her accomplices everywhere - mainly nations of the European Union through NATO, Israel, Australia, Japan, South Korea and other Asian nations, countries of Africa, and so on.

Such is the frightfully immense power and authority of this office!

Positively and constructively harnessed, this office brings hope and development to people and nations in need. Conversely, negatively and destructively used, this office wrought destruction, suffering and death to people and nations alike.

Most sadly, the world witnessed more of the latter than of the former!

It can be appreciated that many would not dare venture to criticize or offend this office and the person occupying it, for obvious reasons of vested interests and, or, fear of retaliation. Of course, there are risk takers who dare to stand up to this powerful office, and, in one way or another, they do pay some price!

External, objective counsel from conscientious minds with the sole interest of the collective, peaceful well-being of humanity and the world, whether American or otherwise, represents valuable feedback to this most influential office.

Behaviour and conduct, at personal and professional levels, both nationally and internationally, must be in line with the importance of this office.Whether

willingly or otherwise, leaders and peoples of nations all around the world, watch and follow what this office says and does.

Consequently, whosoever sits in this office must be of the highest ethics, morals and conscientiousness, not only for the sake of the people of America, but also for the sake of the rest of the world.

The word of the president of the United States of America are not only looked up and paid attention to, but depended on!

And, not only by Americans, but also by the world at large!

If the words of the President of the United States of America cannot be depended on, whose words can the world hold on to?

Current, second-term President, Barack Obama, must be reminded of this, and in the clearest and most vociferous way possible.

Rescinding and reneging on pledges made earlier, to do just the opposite, betray insincerity and dishonesty, and destroy honour and credibility that any person holding this office may have. Such pledges include on the very important issue of fulfilling already-agreed-to basic commitments under international treaties.

Hopes and trust are shattered, most probably never ever to be restored.

It is a sad day for humanity and the world when the President of the United States of America goes back on his words!

What a most depressing let-down!

Thus it is with the 2009 Prague Vision, the 2010 Nuclear Posture Review and the 2013 State of the Union Address on nuclear disarmament and global nuclear zero, all torn asunder, all shattered by the about-turn to upgrade the B61 nuclear warheads stockpiled in Europe, to make them more accurate, and thus more efficient, killing and destroying machines.

So, all we are hearing are merely loud, nice-sounding, empty rhetoric?

Demands of internal national politics and horse-trading notwithstanding, arguments that the upgrading exercise does not constitute change in the mission of these warheads do not detract from the fact that this exercise is an upgrading and does improve them, and will probably spark similar effort to upgrade the destructive mission, efficiency and capabilities of the nuclear arsenals of rival nuclear-armed countries.

So, Mr President Barack Obama, Look what you have just done!

By one singular move, you have nuked your own sincerity, honesty, credibility, and honour,

demolished the hope and dependency of people and nations all around the world on the Office of the President of the United States of America,

disqualified yourself, and your nation, from preventing other nations in the development of their own nuclear weapons, and,

most probably spark a nuclear-arms-race with your fellow nuclear-criminals.

A tremendous achievement for a second-term US president!

Now, having a little idea of the damage you have done, would YOU care to RECTIFY?

60 Syria Will NEVER Be Peaceful Again!

There are parties viciously hoodwinking the world that the removal of Bashar Al Assad will bring peace to Syria!

The removal of Saddam Hussein, Muammar Gaddafi, Hosni Mubarak, did not bring peace to Iraq, Libya, Egypt, as touted by these lying hegemonists and their cronies.

Indeed, if at all, all these nations are now thrown into the most destabilizing, continuously escalating violence in their histories, with seemingly no let-up in the daily destruction, suffering and death, inflicted by roadside, suicide and place-of-worship bombings, driven by tribalism, sectarianism, and greedy religious, political, economic, and criminal excesses.

This destructively explosive concoction of such diverse internal and external violent players make *peace and stability near impossible to achieve.*

Leadership of administrations of the international community, who are sincere, honest and serious about wanting peace and stability for any nation must be themselves peaceful and constructive in the first instance.

We will not be, and are not, talking about peace and stability, when we take sides in armed conflicts, and sell and ship missile batteries and other lethal weaponry to any or both sides!

Such actions are only revealing our own selfish hegemony at work!

It is most basic that the first step in any approach towards peace and stability must be the stoppage of the armed conflict itself!

Any side in the conflict that refuses this first step is telling us that it is not interested in peace and stability for the people and nation concerned! Such a party must be told upfront that their refusal is totally unacceptable, and recognition and support for such a group must be ceased and publicized.

Not endorsed by sending arms and more lethal weaponry, supposedly to even up fire-power of the conflicting sides, or worse still, to bring about defeat of the other side, with the naive, childish assumption that the conflict will then end.

Peace-keeping by friends of both sides must monitor the interim ceasefire while the constructive preparation for similar multi-lateral-monitored elections gets underway.

This is the one and only, civil and constructive resolution of armed conflicts anywhere, anytime!

NOT assisting one side to pound the other into submission and the mistaken dream that this will bring on peace and stability!

It is sad and strange that after years and years of countless armed national conflicts by opposing sides all over the world, certain basic steps for the peaceful resolution of such conflicts have still not been adopted, and the world continue to be plagued by criminal, sinful interests taking advantage of, and worsening such conflicts!

The possession of stockpiles of chemical, biological and germ, as well as nuclear weaponry must be, without exception, declared criminal and leadership of guilty nations must be persecuted as criminals against humanity in the International Criminal Court.

The civilized, conscientious world must be prepared to take this step to the hilt if we are sincere, honest and serious about talking peace and stability for any nation, and for the world and its inhabitants,

President Barack Obama's hesitation in entering the Syrian conflict deserves commendation. We pray and hope that he will not succumb to pressures from

hawkish members in his administration, or the other side, or from his arms industry lobby, or seduced by other destructive temptations.

Leadership of other national administrations - Russia, China, India, the European Union, are similarly looked upon to follow such a step, strengthened by the greatest of restraints and resolve!

Let not misguided hegemonic tendencies drive any leader to take the wrong step and sink the world deeper and more widespread into violent turmoil!

It is increasingly clear that party politicians everywhere are unable to provide the kind of quality leadership necessary to ensure good behaviour, and good governance, nationally or globally.

The role of non-party conscientious leaders from society as leaders at national and international levels must be looked at seriously as a viable, constructive alternative to the currently less satisfactory leadership on offer.

Whether it is spring uprising or the uprising of Muslim women in the Arab world, or activists and all their causes in other nations worldwide, conscientiousness, with its accompanying constructiveness and demand for good behaviour, is absolutely necessary.

Lack of these basic elements turn well-meaning protests into destructive violence that sets the stage for more violence, more destruction, suffering and death. And the most vicious of violent, destructive cycles get created and set in motion!

It cannot be over stressed on the need for the identifying and recognition of conscientious members of civil society everywhere, be it in America, Russia, China, the European Union, Myanmar, Japan, North and South Korea, Iran, Iraq, Syria and the Middle East, Africa, indeed anywhere in the world. and for them to be leaders representing society in national administrations and global bodies in policy formulation, decision making and implementation.

This is the key for meaningful peace and stability for the world and for humanity!

61 Devilish Evil CANNOT Be Committed In The Name Of Any Religion!

2013 May 28

The recent beheading of the soldier in London, the cutting out of the hearts of fallen opponents in Syria, the gorging out of eyes of perished police personnel in Lahad Datu, Malaysia, the killings and burnings in Myanmar and Nigeria, wanton injuring and killing with automatic weapons and knives in China and America, bombing at the Boston marathon, disfigurement, disembowelment and dismemberment of slain opponents, killing and consuming the bodies of victims, the throwing of innocent babies and children from tall buildings, and other types of horrifying acts, are all manifestations of evil at the individual and small group level!

At the larger level, there are sworn enemies who live to obliterate each other, those who kill children, women and the elderly in Thailand, Afghanistan, Pakistan, Iraq, Middle Eastern and African nations, and those who kill through drones, rockets and mines, and by chemical weapons, in the past and at present.

They have all always been there, since time immemorial, but not at the frequency and the ferocity of current occurrences, not in broad daylight, and in the presence of the public, as in London.

Evil that is in the most direct opposition to the teachings of good, and respect for life, AND THE DEAD, in any religion!

EVIL AND RELIGION

ARE ON OPPOSITE SIDES

OF THE GOOD-EVIL DIVIDE!

Thus, any deranged individual or group of individuals who commit such evil, atrocious acts on any other human being, are accomplishes of the Evil One itself, willingly or otherwise.

SUCH ACTS CANNOT BE IN THE NAME OF ANY RELIGION !

SO, NO RELIGION CAN OR SHOULD BE BLAMED OR HELD RESPONSIBLE!

Such evil happenings are disturbing and worrying, and need all the focus, strength and joint-action of all who are conscious of such evil.

At no time other than *NOW* is the need greater for *HUMANITY TO RETURN TO THE GOODNESS OF RELIGIONS!*

TO CLEANSE!

TO STRENGTHEN!

To be equipped to fight the evil that forever lurks around the corners and in the midst of humanity, ever ready to drive man and woman alike to commit the most horrifying of acts against fellow human beings!

Religion, for the good in it, not orthodox religious bigotry that stands in the way of the goodness that man should derive from it!

With such awareness and conscientiousness, man must move to acquire knowledge of the religion he espouses, and live his life in accordance with such religious dictates and values, from the personal self, to the immediate family, to community, society and the nation. And, thence, to the world!

It is only through the teaching and the learning of the good of religions, the embracing of such good, and the living of lives guided and dictated by such good, that the manifestations of evils in our lives can be reduced!

And sanity, security and safety, for man, and all other living things and the environment, returned.

For the conscious common person, and for those who see themselves as leaders, whoever and wherever they may be, it becomes their sacred duty to self, family and fellowmen, to spearhead such a RETURN!

For those who choose not to have a religion, the atheists, there are these things called universal good, common virtues, ethics and morals. Though argued as subjective, they can, and still are, embraced as acceptable, and therefore, liveable!

For those who sit at the helms of leadership of nations, the responsibility becomes even more pronounced, the need more urgent, to behave and set good examples for people and nation to follow and emulate, for good to become a shield and a weapon against evil!

THERE REALLY IS NO OTHER WAY!

Only those who sow goodness, as enshrined in religions, can expect to reap goodness, including well-being, safety and security, for self, family, community, people and nation!

62 KOREAN BABY STEPS OF HOPE !

The North has its North Korean Committee for the Peaceful Reunification of Korea, while the South has its corresponding and parallel Unification Ministry!

In the deepest recesses of their conscientious minds, and in their heart of hearts, both the leadership and the people of North and South Korea long for, and eagerly await, unification, families becoming whole again, and the peninsula united after years of wasteful, misguided, evilly-orchestrated animosity!

No political ideology is worth such disunity, such heartbreak!

No external, ill-intending manipulators should be allowed to continue their sinful tasks of sowing conflict, broken people and divided nation !

Let the current baby steps realize the ultimate hope of sincere, and honest, reunification of one people, of one peninsula !

Let Panmunjom be the starting point for the challenging but NOT insurmountable journey that must, and will, traverse and permeate the whole Korean Peninsula, villages, towns and cities, culminating in the family meeting of the highest leadership of both halves of the same peninsula.

Let there be NO Mistake!

No Presumption that it will be an easy task!

The journey will be long and arduous. There will be many potholes and as many cave-ins. Danger will lurk at strategic corners and bends! Many will seek to derail.

Many more will attempt to seduce with evil fruits. Still others will incite, provoke and fan differences and reignite the destructive divisiveness of quarrels and conflict.

Let the genuine desire to see a reunited people, together with a reattached peninsula, drive effort.

And, let this reunification bear testimony to the people of the world that despite past enmity, forgiveness can be the order of the day, and unity is possible, rewarded by the joys and love of family togetherness once again, and constructive hope for the peaceful future as one people, one peninsula, disallowing and denying political ideology its' past divisive role !

Let more positive visionary thinking replace past, less mature and destructive tendencies!

Let mutual security assurances drive away the suspicion and insecurity that each half created for the other.

63 THEY CANNOT BE CALLED 'MUSLIMS'!

2013 JUNE 20

The holy monotheistic religion of Islam, with its' Prophet Muhammad and its' holy book Al Qur'an, centres on peace -

peace for those who declare themselves its' followers, and endeavour diligently to obey its' dictates; and

peace for others who are not yet Muslims, and who may come into contact with such Muslims!

Even other living things, plants and animals, and the environment, are assured safety, security and well-being!

These, then, are the objectives of the strictness of the teachings, codes of personal and societal behaviour, and systems of justice and punishment in Islam!

When man insists on gross misbehaviour, no quarters should be expected, and when misbehaviour reaches its set limit, then the full force of the attending punishment is duly, and justly, executed!

Such are the essence of Islam on those who choose it as their religion, and are therefore obligated compulsorily to obey it!

Of course, as always with man, things get lax after a while, and driven by egoism, arrogance and orthodox bigotry, coupled with greed and sectarianism, wrongful self-righteousness creeps in, and dictates conduct towards ALL others, fellow Muslims and non-Muslims alike, other living things and the environment.

So, we have name-calling of fellow 'Muslims' as infidels, to the point of unjustified physical attacks because performance of prayer rituals is not totally similar.

Due to varied cultures, upbringing, and mother-tongues, and the process of religious propagation over time, small variations should be expected and accepted.

Further, isn't total humility, sincerity and submission to Almighty Allah SWT during the performance of prayers, of greater significance than minor variations in hand and body movements?

Of what use is a 'perfect' system of physical movements during prayers, when humility, sincerity and submission are not there?

But, NO!

It has to be carried to the worst limits of physical violence to 'correct' such wrong' movements.

Where is the peace to self and to others that the religion is supposed to bestow on all those who profess it?

When it is ONLY Almighty Allah SWT who determines which physical movements are acceptable and which are not !

Likewise, the House of Allah SWT, the mosque, and this is an even more serious matter!

Wonder who determines whether a structure or building is a House of the Almighty?

Is it man or a particular nation, or a group of men, or a group of nations?

Perhaps, a particular group of humans who declares to the world that THEY follow Islam as their religion, and so qualify to be called 'Muslims' but who *also* called themselves Sunnis?

Or, is it this other group of humans who likewise announces to the world that THEY are followers of Islam, and so are 'Muslims', but who also address themselves as Shiites?

Then, each group takes it on themselves that they are the ones who determine which structure and building can be a House of Allah SWT, and each group then gives themselves the unquestionable right to destroy all other such buildings and structures, worshipers present regardless!

Talk about usurping authority!

We are all of the opinion that **ONLY The Almighty Possesses the Power, the Authority and the Right to Determine and Accept which structure and building can be a place of worship for HIM, and ONLY HE ALONE!**

See the irony now?

We have people who see themselves as, and so proclaim to the world that they are, followers of Islam, and so are 'Muslims' and that Allah SWT Is The One And Only God they submit to and worship, and the mosque is HIS House of worship. and HIM ALONE !

At the same time, these very same people can, as and when they see fit, bomb, rocket and machine-gun, structures or buildings they unilaterally do not consider as Houses of Allah.

Or, worse still, they accept them as Houses of Allah, but they still proceed to bomb, rocket and machine-gun these mosques, together with all worshipers therein, simply because they consider these other groups infidels, and whatever else!

Just how misguided and lost can some people be ?

Now, for the million dollar, or is it riyal, question!

Can someone, who admits oneself as a follower of Islam and worships Allah, but freely, without second thoughts, definitely without remorse, most often with meticulous planning and execution, destroys the House of Worship of Allah, with other humans who have similarly profess and proclaim submission to Him, and follow His religion of Islam, can such a being be called a 'Muslim'?

Violating the House of Worship of Allah with such destructiveness along with the murderous killing of brothers and sisters of the same faith, whatever sect, tribe or nationality notwithstanding, must surely constitute the gravest of sins against Allah SWT and fellow 'Muslims'!

So, Sunnis, Shiites, and other sectarians, tribes and groupings, including, but not limited to, Al Qaeda, Taliban, Boko Haram, and others, quite frankly, and most seriously, perhaps

"YOU CANNOT BE CALLED MUSLIMS"!

The situation is the same for men and women who proclaim to the world that they are followers of this religion, or that religion.

You CANNOT commit atrocities on your fellow brothers and sisters of the same faith and yet want to be recognize as followers of your stated religion!

Similarly, you CANNOT commit cruelty on other human beings in the name of your religion, whatever it may be - Buddhism, Christianity, Judaism, Hinduism, Sikhism,

So, violent and murderous Buddhists, Christians, Islamic Terrorists, Jihadists, or similar religious others, are merely misnomers used by those who are painfully ignorant!

And,

GOD Is The ALL-KNOWING!

64 Fossil Fuels to Nuclear - Most Certainly Not From the Frying Pan Into the Fire!

2013 Nov 11

Super Typhoon Haiyan is reportedly the worst tropical storm yet to hit the Philippines, packing winds in excess of three hundred kilometres per hour, spewing horrible, wet destruction to properties and death to lives, human and all else, and severe flooding, in its' wake.

Already, looting, rape and other crimes are taking place as the shocked population struggles in futility to meet the overwhelming physical and emotional challenges brought on by this enormous natural catastrophe, the viciousness and magnitude of which they have never imagined, much less expected.

In the days, weeks and months to come, diseases, emotional stress and trauma, together with increasing basic needs, will surely create a worsening human calamity!

Without sincere assistance from the rest of the family of nations and conscientious society everywhere, the Philippines administration will be most harshly tested in this hour of great national need!

Humanhood International urges ALL to REVIVE the CONSCIENTIOUSNESS in themselves and CONTRIBUTE in whatever way possible, to help alleviate the hardships of OUR BROTHERS and SISTERS in ALL the AFFECTED AREAS!

HAIYAN joins the ranks of all the numerous tropical storms to hit nations all over the world this year, and in the past, many of them super in themselves, for their ferocity and the sheer speed and destructive force of their winds.

Melting snow caps and icebergs, rising sea-and ocean water levels, erratic weather conditions - high temperatures and drought in certain parts of the world, and incessant, heavy rain and flooding in others, and other environmental and atmospheric abnormal behaviour, are but real-life and real-time manifestations of rigorous, upheaving climate change!

These, together with tsunamis and tidal waves, alongside tremors, earthquakes, and volcanic eruptions of increasing frequencies and spread, convey clear, definite and undeniable messages to mankind, if and when we find the humility, the wisdom and the willingness to be taught by natural phenomena!

The divestment and inevitable, subsequent total migration away from fossil fuels, especially petroleum, are NOT OPTIONS, and MOST CERTAINLY NOT so that THEY may be REPLACED by NUCLEAR AS ENERGY-SOURCE, together with their accompanying up- and down-stream activities!

It is good that people have awaken to the ill-effects of fossil fuels and taken definitive steps to move away from these energy sources.

Green alternatives of hydro or water, solar, wave, wind,, will *REDUCE* the *CARBON FOOTPRINT* of fossil fuels and thereon *REDUCE GLOBAL WARMING and thence the RESULTANT CLIMATE CHANGE.*

We would not be so ambitious as some others, to venture to talk about reversal of climate change. when we can achieve reduction, that in itself would be an encouraging initial accomplishment!

Smog pollution that causes respiratory deaths, is now recognized as another of fossil-fuel consumption's inescapable ill-effects, and adds to its' list of negatives that drives divestment efforts away from fossil fuels to the momentum it is at today!

Of course, there is plenty of room for complete divestment, and total migration away from all up- and down- stream activities of fossil fuels, principally petroleum!

The following are the more serious reasons which we think why:

The massive global daily extraction of petroleum reserves from deep under accelerates the movement of the huge tectonic plates causing underground upheavals that result in tremors and earthquakes;

Tidal waves and tsunamis of increasingly destructive and disastrous intensity and frequency;

Added to these, the extraction of petroleum reserves denies mother earth of her coolant, increasing temperatures and pressures at her core, manifested by the similarly more numerous volcanic eruptions of greater violence worldwide, alongside the increasing temperatures of the deepest depths of the oceans.

The fate of fossil fuels, principally petroleum, is clearly sealed to those of us who have the modesty and the moral fibre to be so taught, and to be so committed to act accordingly!

It is not only fossil fuel divestment that is the order of the day, but clearly, and more importantly, the pursuit of green alternatives without leaving chemical footprints in their paths, that have to be endeavoured with the greatest of relentless effort and decent responsibility, to replace the current fossil-fuel economic, social and industrial landscapes and environment.

However, to suggest that nuclear be developed under full-steam to fill the gap to be left by fossil fuels, is tantamount to introducing an energy source that is millions of times more destructive and life-threatening, not only to humans, but to ALL other life-forms as well - radioactivity can be carried by matter of any kind in all the three physical states of solid, liquid and gas!

Added to all these, the danger that radioactive material purification and concentration, to produce the fuel for nuclear power stations, will provide the

raw material for nuclear weapons, the case against nuclear should be crystal clear to all who regard themselves as morally decent, responsible and peace-loving human beings!

At a time when conscientious human beings worldwide are working hard to achieve global nuclear zero via :

No uranium mining;

No nuclear power stations;

No nuclear-powered vehicles;

No nuclear weapons;

Accelerated decommissioning of existing nuclear warheads;

Preferring charges of failure in the diligent discharge, and dereliction, of duties on those international agencies the responsibilities of which are to ensure on-schedule such decommissioning;

Pronouncement of criminality and initiation of crimes against humanity charges on the political and administrative leadership of ALL nuclear-armed nations;

Testing deep-sea water samples and creatures that have come to shore to die, for radioactivity in the event criminal-politician-led rogue nations dump their toxic nuclear wastes in the deep waters of the oceans;

It is only when there are no more nuclear-armed and nuclear-powered nations in the world that members of the international community can unite and enforce the No-Nuclear Rule on ALL nations of the world, particularly nations such as Iran, North Korea and others, similarly erroneously-inclined, impatiently waiting in the wings!

Let not greed, hegemonic lusts and primitive savagery drive us to continue our unwise, unsustainable and self-destructive economic and industrial 'development' and 'growth' paths!

Humanity DOES NOT NEED more Haiyans, tsunamis of 2004 and the numerous earthquakes and volcanic eruptions, to bring us to our individual and collective knees before we wake up to, AND ACT DECISIVELY ON, OUR OWN FOLLIES!

65 HUMANITY - ART THOU IN DIRE STRAITS!

2014 MAC 01

The openly restaurant-serving of roasted human head and cooked human flesh in the menu in Nigeria marked another horrible, worrying milestone in the continuing decadence of man, back to the primitive barbarity of old.

The human skull and flesh are most probably from the corpses of enemies killed in the on-going tribal hostilities that erupted as far back as can be remembered.

Adding to this cauldron of human bestiality is the embrace of different religions by the opposing tribes, commonly Christianity and Islam, religions the flocks of which have been mutually antagonistic from time immemorial.

Coupled with the lusts of hegemonic powers and their immoral, and sinful, arms industrialists, the stage gets set for prolonged, unacceptable violence of such shocking cruelty, including, but not limited to the gorging out of the eyes, the cutting out of hearts and eating them in-situ, the beheading, mutilation, disembowelment and chopping up of the bodies of both slain and fallen, but not yet dead, opponents - men, women and children, of all ages, all included, all mercilessly, most cruelly beyond imagination!

It is most regrettable that those who looked on themselves as national and global political, commercial, religious and community leaders everywhere, allow themselves to be so criminally and sinfully sucked into such shamefully petty quarrels and conflicts of this nature that are nothing but mere primitive and egoistic differences over survival and turf!

Of course, it cannot be discounted that some are most willing participants, ever on the look-out for tools and opportunities to further their greedy and treacherous lusts!

So it is with other unfortunate nations of the African continent such as Sudan and the Middle-Eastern countries, and elsewhere in the world. While the bigger portion of their respective populations eke their livelihood out of the barren and hostile ground, frequently without recourse to water.

It is distressing that those who look upon themselves as leaders in these lands remain unable to grow out of their narrow and shallow selves, and so continue to be shackled by their tribalism and past enmity, instead of awakening to the dire straits of their communities, learn, plan and execute meaningful programmes of peaceful co-existence, sharing and collectively progressing qualitatively together!

Most sadly, the more developed nations of the world fare no better!

While nationally, they may have graduated from basic survival and turf wars, many are seduced so much by materialism and the lure of money that any and every manner of abuse are harnessed just to accumulate more wealth, more materialism, never mind whatever the cost.

So, laws are bent or treated as non-existent, the atmosphere gets murdered till the air in no longer breathable and people have to move about with respiratory masks along with carless- and bicycle- days, millions of hectares of virgin jungles are deforested, never mind the green lungs, the water-catchment areas, the erosion of fertile top soils, the siltation of rivers causing flooding, the destruction of rich biodiversity,

Just so that they can land their fat, greedy hands on the timber and increase the acreage of their plantations, or build more dams, in their quest for their insatiable, endless and limitless greed!

Meanwhile, *nature responds to man's cruelty to the environment and his abuse of her resources!*

Climate change of increasing severity, with the whole spectrum of natural disasters, accompanied by the continuum of temperatures from negative to burning hot, trashes the most developed of nations, disrupting normal life

in every way imaginable, destroying property and crops, and maiming and taking lives.

And, mutated viruses, such as more stubborn strains of tuberculosis, malaria, dengue, Ebola, MERS CoV and SARS, bring new challenges to the medical fraternity, on all fronts.

Accompanying all these, man's misbehaviour, driven by his continued refusal to return to goodness and keep his greed in check, compounds and intensifies the problems that threaten his very survival!

Let no one be mistaken - When calamity strikes, it strikes ALL!

Regardless!

The rich!
The poor!
The well-heeled!
The simple!
Those in high positions!
The common man and woman!

NO ONE ESCAPES!

66 MALAYSIA : 'ALLAH', SHARIAH, HUDUD, THE TEN COMMANDMENTS, - PIOUS OF ALL RELIGIONS WORK TOGETHER!

2014 MAY 13

Believers of Monotheist GOD hold that HE is the SOLE CREATOR of all, the seen and the unseen, on earth and in the sky. In fact, everything everywhere in the universes!

The Singular LORD, MASTER and GOD of all, now and in the HEREAFTER!

The WISEST, The ALL-KNOWING, The ALL-POWERFUL!

Religions, all of them, teach goodness, and are for all of mankind, everywhere..

*Hence, all religious pious should be on the **same side of the good-evil divide**, NOT PITTED AGAINST EACH OTHER, in the desire to embody the goodness of the religions professed!*

The desire to be pious is not extremism or fanaticism!

No religion teaches extremism or fanaticism, and militarism!

But, just as everything else, there will be the false ones - those who proclaim themselves to be ardent followers of religions, but are only misusing religions for their own selfish ends!

The vigilant among us need to be forever on the lookout for such individuals and groups! Fortunately, time is a good revealer of such people.

When a person declares allegiance to a religion, it is expected that such allegiance be as complete as possible.

Put otherwise, it means that as much of the teachings of the religion are learnt and practiced in daily life as is humanly possible. It has to be **THE WHOLE PACKAGE OR NOTHING!**

Of course, man, being so full of defects and weaknesses, can be expected to fall short, often most seriously, in his religious obligations and duties.

So, we have selective adherence to religious dictates, some left out due to ignorance, others neglected on purpose, yet others deviously.

The humble, true and honest devotee endeavours to live life as fully in compliance with, and as completely as possible, all the rigors of the declared religion!

Against this backdrop, it is clearly absolutely necessary to know as completely as possible, ALL that are contained in, and demanded by, one's declared religion!

To leave out any part would render one's faith incomplete and weak!

Thus, for Christians, the Ten Commandments are compulsory, along with other teachings of the Bible.

It is inevitable that when a religion is spread to people of other lands, the scripture gets translated into the languages of the said people and they will have their own names for Monotheist God in their own languages!

When two or more religions speak about Monotheist God, they speak about the Same Entity. Thus, names in different languages for this common Monotheist God inevitably become interchangeable!

There is NO PROSETYLISM BECAUSE GOD IS ONE AND THE SAME!

It will be good when groups of followers remain faithful to their religion of choice, respect it, and not venture underhand and overhand methods of missionary work, but instead strive hard together to improve the quality of worship of each of their respective flocks, and not just the ritualistic aspect!

For Muslims, Rules of Islam, Rules of Faith, and other components of the Qur'an fall into mandatory and choice.

The difference in Islam being that it caters to a complete way of life both on earth and for the hereafter.

Guidance and rules are there for all spheres of human life - personal, family, societal, social, financial, commercial, political, legal, penal code, and all else.

Islam's legal system is commonly referred to as Shariah while one part of the penal code of Shariah is referred to as Hudud.

The word hudud basically means limit, meaning that Hudud Penal Code is applied when crimes committed are at the limits set or prescribed.

By this consideration, no person can proclaim oneself a Muslim, unless and until the initial pronouncement of the two Articles of Faith are accompanied by subscription to all the rules and dictates for ALL spheres of life on earth, including, but not exclusive to, Shariah and Hudud, alongside the learning of the Prophet's Traditions as additional guidance for life as a Muslim!

Islam was sent down to a people who were misbehaving in the worst way possible as human beings.

TO ADDRESS, CONTAIN, REMEDY AND PUNISH SUCH BESTIAL BEHAVIOUR, RULES HAVE TO BE, AND ARE, STRICT AND PENAL CODE HARSH!

Public flogging, amputation of limbs and death by stoning and beheading are but just some articles in the penal code ensemble, which is wide and encompassing, but qualified with mechanisms for mitigation in all instances.

Anyone with intention to debate and take positions on Shariah and Hudud ought to, in the first instance, most humbly and suitably, have some basic knowledge about Islam and its various components.

Without such basic knowledge, positions taken will be, at best, misinformed and uninformed, and, ***MORE SERIOUSLY, ERRONEOUS!***

All these in no way convey any superiority on Muslims, their race or their nation, over others!

*Evaluation and acceptance of one's religious performance is **ENTIRELY** the **INDISPUTABLE** and **EXCLUSIVE DOMAIN**, and **ABSOLUTE AUTHORITY**, of the **ONE** and **ONLY OBJECT** of **WORSHIP** of, and by, **ALL!***

All must remember that *Islam is one of the religions of Monotheist God, and **ALL GLORY GOES ONLY TO HIM, AND HIM ALONE!***

*If and when, **HE** so **DESIRES**, **ALL** Men and Women Everywhere, without exception, **WOULD BE BELIEVERS IN HIM, AND HIM ALONE!***

National constitutions are documents drawn up by founding fathers to guide the development and growth of nations.

Just as founding fathers are imperfect human beings, national constitutions can be expected to defective and have inadequacies, requiring consistent and regular fine-tuning to suit evolving circumstances and the state of development of the peoples and the nations.

There is *NO* national constitution in the world that had not undergone some manner of amendment to improve it to accommodate prevailing national conditions and state of affairs, and facilitate further and future development!

While credit is given to founding fathers, and mothers, for their national vision, it would be too much to expect them to be able to extrapolate the conduct and the development of the people and the nation well into the future, accurately or otherwise!

For Muslims, Shariah and Hudud ARE NOT OPTIONS, and when national constitutions have to be amended to provide for these, then that JUST HAVE TO BE DONE!

It is NOT any one group gaining the upper hand over the rest of the citizens, or Muslims being superior, or oppressing the rest through the use of Islam!

Whether proponents of, or opponents to, Shariah and Hudud, it MUST be ABSOLUTELY CLEAR TO ALL, that INTENTIONS MUST BE SINCERE AND HONEST, NOT FOR POPULARITY, BROWNIE POINTS, POLITICAL MILEAGE INCENTIVE, or OTHER REPULSIVE, SINFUL REASONS!

WANTING SHARIAH and HUDUD IS JUST COMPLETING HUMBLE SUBMISSION TO GOD ALMIGHTY!

Islam is one of the religions of Monotheist God. No one is above Islam - no 'royalty', political leader, family, group, race or nation!

Any disrespect to Islam, in any unholy manner, will most certainly be met by retributive reciprocation from Him, Who Seeth all and Who Knoweth all!

Let everyone be so forewarned!

No one is exempt!

While man continues his debaucherous and barbarous demeanours, that deteriorate into new depths of depravity, can man, should man, expect any lightening of punishment?

Current Malaysian secular laws are UNABLE to PRODUCE the JUSTICE that the PEOPLE WANT and DESERVE!

Custodial deaths, murders, embezzlement and commercial crimes and misdeeds, race-based and race-driven discriminatory policies, the propagation and unrelentlng pursuit of insatiable, endless and limitless greed by any, and all, means, ALL DO NOT HAVE THEIR PLACES IN A SYSTEM BASED ON GOD'S LAWS!

The KEY FACTOR is to ENSURE that TRUE JUSTICE is SERVED, and those who had been abusing their positions and stealing land and wealth from the nation, through their devious plots, and the commissioning of all other crimes, presently untouchable by the existing legal system and sinful obsession with racial traditions, be brought to book, and meted appropriate punishment accordingly!

No innocent need worry or fear Shariah and Hudud!

It is only the debauch, the greedy, and the criminals of whatever crimes, who have reasons to worry and to fear!

So all manners of flimsy excuses are forwarded to oppose - from being unjust to non-Muslims and creating disunity, to chaos from dual justice systems!

Incidentally, is Malaysia currently SO JUST, not only to non-Muslims, but to Muslims as well?

Is it presently SO UNITED?

Just the simple and basic naming of the national language as Bahasa Malaysia itself meets with so much reluctance and resistance, more so the

removal of the race column in administrative forms, officially, supposedly for the monitoring of the economic performance of each community, and for statistical purposes!

While all these are merely truthfully revealing a gross absence of sincerity and honesty on the part of the political leadership in their boastfully declared desire to create a united people, and a severe lack of creativity, innovation and competency on the part of those in the civil service entrusted with the said duties

Thus, community traditional elements and the perpetuation of race take greater importance and priority over the teachings and guidance of the holy religion of Islam itself!

All are most clearly aware that the obstacles that are standing in the way of true unity of the people are the *RACE-BASED and RACE-DRIVEN DISCRIMINATORY POLICIES THAT CATEGORIZE, AND SO DIVIDE, THE PEOPLE, AND SUBJECT THEM TO RACE-BASED PREFERENTIAL, AND SO UNJUST, TREATMENT, WHEN ISLAM MOST CLEARLY DICTATES THAT 'WE CREATED PEOPLE IN DIFFERENT COMMUNITIES SO THAT YOU MAY GET TO KNOW ONE ANOTHER'!*

NOT SO THAT YOU MAY, FOR WHATEVER REASONS, RESORT TO RACE-BASED, RACE-DRIVEN DISCRIMINATION!

Preferably, Shariah and Hudud be led, and administered, by non-bigoted, non-partisan, non-gender-biased, non-racist, virtuous men and women of high integrity who truly subscribe to the dictates and the laws of Islam, and who alongside ALL OTHER RELIGIOUS PIOUS, CHOOSE TO, UNRESERVEDLY, SERVE GOD, RATHER THAN MAN!

All party=politicians - Pas, Umno, PKR, DAP, MCA, MIC, and their cohorts BUTT OUT, and STAY OUT!

Where secular laws failed to address, contain and remedy the worsening ills of society, especially by those 'untouchables', LET GOD-INSPIRED LAWS DO THE JOB!

LET CONSCIENTIOUS LEADERS AMONG THE RELIGIOUSLY-PIOUS TAKE THE LEAD!

AND, ALMIGHTY GOD KNOWETH BEST!

67 INDONESIA,
SHOULD BE REWARDED!

2014 JUNE 10

Indonesia›s presidential election is currently underway. Newly ex-Indonesian President, Susilo Bambang Yudhoyono,›s last many months in office witnessed the formulation of trade policies and business rules that protect Indonesian interests more than investors'.

It takes courage and a genuine love for the Indonesian people and nation for him to do this, even though Indonesia pays a price for this!

There will be loss in investor confidence. Trade and current balance will be affected. The rupiah will fall.

However, *no true political leader, worth his grain of salt, should be so hypocritical and traitorous as to betray people and nation by doing otherwise, unless they or their cronies are the beneficiaries of people- and nation- treacherous trade and investment policies, rules and practices!*

And, these have certainly taken place in so many countries, Indonesia's closest neighbours included!

Promoters of single regional markets and trade partnerships, such as the Association of South East Asian Nations, or ASEAN, single market and the Trans Pacific Partnership Agreement, or TPPA, are nothing but merely greedy.

While the size of the market may be bigger, it also means one's own country will be opened up to greater competition, and by more experienced and better-connected and equipped business people, who also happen to have greater access to far larger financial backing.

Playing fields will not be level for the simple reason that nations, such as those of ASEAN, are at different stages of development, both people- and nation-wise, and so have differing skills and experience competencies, a lot of the time exposing them to great disadvantages.

While jobs may be created, how many will be filled by locals and how many by imported personnel?

Foreign investments in the financial markets - how much of these are clean money, and, now much are dirty money - from corrupt practices by those in high positions, embezzlements, from the sale of drugs, from ?

Financial markets offer an excellent and most convenient channel for money laundering!

The political leadership of ASEAN nations must ponder deep and hard before agreeing to a single ASEAN market. Likewise those nations targeted for TPPA! Otherwise, it will be the common men and women on the streets who will end up paying a heavy price for the perfidy of their greedy, immoral and sinful political leaders!

Any nation that embarks on self-cleansing, as Indonesia is doing, putting Governors, Chief Justices and ministers in prison for abuse of positions and corruption earn **GOODNESS POINTS**, that should see it enjoy greater goodwill and preference from the international community!

So, unlike those nations, again Indonesia's closest neighbours included, where the greedy, immoral and sinful political leaders, both past and present, who have amassed illicit millions and billions, not only are untouched by the law, and so not brought to book to pay for their abuse and criminal misdeeds, but continue to enjoy high status and even rewarded with the highest honorary awards and positions of the land!

The world needs a new system of appraisal in which efforts to look after one's own people and nation responsibly and properly, and cleaning up yhe whole system of national administration, be rewarded, while the

continued propagation of insatiable, limitless and endless greed be obstructed, reprimanded and punished!

This approach facilitates sustainability of the environment and natural resources, and thereby life, and reduces continued destruction of water, air, resource, securities, putting a long-overdue correct value on good behaviour and proper conduct in the leadership and administration of people and nations!

HUMANHOOD INTERNATIONAL

2012 JULY 02

Propagating The Singularity Of A Conscientious Plural Humanity

ABOUT US

Humanhood International Is A Vehicle And Platform:

For The Development and Propagation of the Singularity of a Safe, and Secure, Peaceful and Conscientious Plural Humanity;

On A Foundation of Universal **Virtues, Ethics and Morals; Humanhood International Works Towards Greater Participation of** Conscientious Members of **Civil Society Worldwide :**

In Policy Formulation, Decision Making and Implementation, and General Administration of Nations;

Through Constructive, Collaborative and Cooperative Engagements with Similar-Minded Individuals and Groups.

We are communicable via:

humanhoodinternational@yahoo.com
ghazaliphkho@yahoo.com

ACKNOWLEDGEMENT, TRIBUTE AND DEDICATION

Humanhood international acknowledges the contributions, in words and deeds, of all conscientious members of society, of both genders, of all age groups, everywhere, who selflessly endeavour to bring about positive changes for the betterment of themselves, their families, their communities, their nations and the world at large.

It is due to these individuals and groups, their sacrifices, sometimes the ultimate - that of their lives, that there remains hope for mankind, other living creatures and mother earth, as we grapple daily with the increasing number of seemingly unsurmountable challenges arising from severe man-responsible climate changes, and earthquakes, volcanic eruptions, tidal waves, and diseases, and destruction of basic securities of air, water, food, shelter, health and livelihoods.

This book is a humble tribute and dedication to these conscientious heroes and heroines, both past and present, and to those who will similarly step into their shoes in the future. They serve as noble inspirations and motivators for the rest of us.

Conscientiousness and the courage to speak and act by all can bring on the positive changes necessary to correct the serious flaws in our past and present conduct, and ensure a more sensible, sustainable, peaceful and meaningful future for all of us.

The author most humbly and most thankfully, acknowledges the permission, compassion and blessings of Almighty God for his humble existence, and without Whose Grace this book will never be.

Thanks are also due to all the sources of information, he printed and social media, really too numerous to name. You are all acknowledged!

Last, but not least, the team at Partridge Publishing Singapore, with their infinite patience and assistance, without which this book will not see the light of day.

Thank you all!

ABOUT THE AUTHOR

Ghazali PH Kho has a background in chemistry and management and conducts his life founded on universal virtues, ethics, and morals.